IMAGES
of America

ESSEX

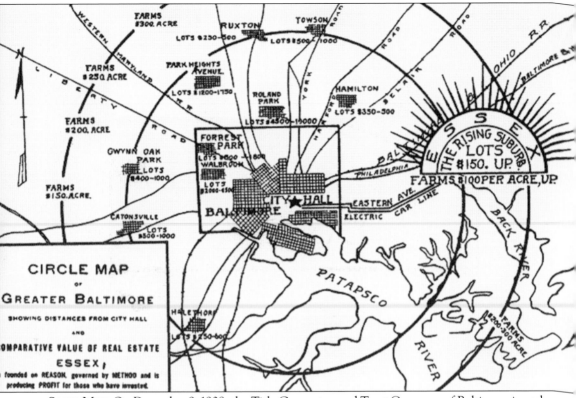

SALES MAP. On December 9, 1908, the Title Guarantee and Trust Company of Baltimore issued a $50,000 policy to the Taylor Land Company for 12,000 acres known as Paradise Farm. In June 1909, surveyors began to stake out 400 improved building lots for the development of Essex. The new suburb offered 50-by-145-foot lots for sale starting at $100 with a discount for cash. (Courtesy Heritage Society of Essex and Middle River.)

ON THE COVER: The Vigilant Volunteer Fire Department is shown in 1917. Vigilant volunteers from left to right are (seated) John Zimmerman, ? Briggs, Pres. Adam Knierim, ? Martin, ? Petit, John Hughes, and Will Scheler; (standing) Walter Johnson, ? Duer, Christopher Brawner, Capt. Frank Kimmel, William Dorsey, John Lang, Lloyd Johnson, Ross Woods, and Al Duer. The captain was Conrad Gail. Vigilant boasted the first county-owned truck housed in a volunteer building. (Courtesy Heritage Society of Essex and Middle River.)

IMAGES
of America

ESSEX

Jackie Nickel

ARCADIA
PUBLISHING

Published by Arcadia Publishing
Charleston SC, Chicago IL, Portsmouth NH, San Francisco CA

Printed in the United States of America

Library of Congress Catalog Card Number: 2006924401

For all general information contact Arcadia Publishing at:
Telephone 843-853-2070
Fax 843-853-0044
E-mail sales@arcadiapublishing.com
For customer service and orders:
Toll-Free 1-888-313-2665

Visit us on the Internet at www.arcadiapublishing.com

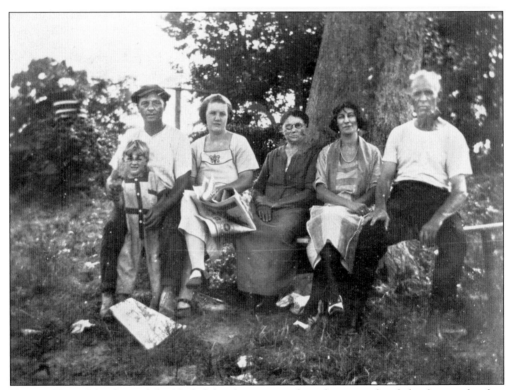

FAMILY TREE. Members of the Nickel family pause under a large maple while clearing land at their Rockaway Beach property shortly after acquiring it in 1916. John H. ("Hon") Nickel, left, was a prominent Baltimore businessman and avid fisherman. In Essex, on the shores of Middle River, he found the perfect spot for his family to drop anchor. To him—my grandfather—and to all my family, past and present, this history is dedicated.

—Jackie Nickel, October 20, 2006

CONTENTS

ACKNOWLEDGMENTS

Sincere appreciation goes to all those who have helped to bring this history of Essex to print. When I first approached the Baltimore County Public Library for assistance, I was greeted with an enthusiastic "an Essex history is long overdue!" But as I soon found, historic photographs of the area are not readily available in a form suitable for publication. Thus I sought out and approached individuals and families who have their own longtime roots and histories in Essex.

To those wonderful people who entrusted me with their treasured photographs, in particular Daniel Weber Hubers and Mary Pospisil, I am extremely grateful. Your friendship as well as your trust continues to inspire me. To the *Avenue News*, where I got my start in this writing business, and to Managing Editor Jean Flanagan, thank you for opening the archives where I rediscovered much of my own career past.

To the officers of the Heritage Society of Essex and Middle River, thank you for your generosity in sharing our history. To Slava Matejka Mowll and her daughter, Nancy Mowll Mathews—who now live in Massachusetts—and their cousin, Lynn Gittings, thank you for sharing your wonderful photographs and memories. To my friends and neighbors, JoAnn Weinkam Weiland and Marcy Bereza Siegman, thank you for digging out those old photographs.

Others to whom I am extremely grateful include Ballestone Preservation Society and Michael Bosse, Baltimore County Public Library and Richard Parsons, Paul M. Blitz, Beverly Brady, Dr. Jack Breihan, Gloria and Richard Bruzdzinski, Eric Carl, Tom and Joyce Clark, the Dundalk–Patapsco Neck Historical Society, the Enoch Pratt Free Library, Essex Revitalization and Community Corporation, Glenn L. Martin Maryland Aviation Museum, Dr. Bob Headley, the Historical Society of Baltimore County, Gary Jennings, Lightner Photography, John McGrain, Henry Oldewurtel, Bob and Joan Page, Ray Porter, the Riley family, L. Keith Roberts, George Weiss, Dorothy Wunder Schreiber, the Tutchton family, and William Woutila.

INTRODUCTION

Essex is a fascinating town with a history well worth repeating. While a few histories of the area have been published, all were done on a small scale and now are out of print. The recent Baltimore County–supported Renaissance of Essex and Middle River, which is anchored by the main thoroughfare of Eastern Boulevard (the "Main Street" connecting the two) has drawn extensive press coverage and an influx of new businesses, homeowners, and visitors. Newcomers are intrigued by the community's roots, which many old-timers, through this book, are eager and happy to share.

In the 15th century, only the Susquehannock Indians knew the paradise that was to become Essex. Traveling from Pennsylvania to reap the seasonal harvest of local hunting grounds, the Native Americans also enjoyed the bounty of the bay and the fruits of the fertile earth.

Around 1607, Capt. John Smith disturbed the solitary occupation of the tribe, which he described as an extremely tall, strong, and hardy band. Traveling from England to the first settlement in America at Jamestown, Virginia, he soon set out to explore the magnificent waterway called the Chesapeake Bay. Smith wrote with delight, colorfully describing the fish and fowl so abundant in the region. Much is being written about his exploration in 2006, approaching the 400th anniversary of his first voyage into the upper reaches of the Chesapeake.

In the decades to follow Smith's discoveries, many settlers arrived on the shores of Maryland and established towns and cities along the waterways. And as centuries passed, farmers gravitated east from Baltimore City to plant spinach, corn, tomatoes, and other crops. Yet by the early 1900s, only a few dozen farming families occupied the land that was to become Essex. Many immigrants who were delivered to the city's docks in the 1800s from Germany in particular started their new lives in the East Baltimore neighborhoods of Fells Point, Highlandtown, and Canton. As these families became established and were able to save a few dollars, they began to look for land outside the confines of the city. Heading east on a shell road, they discovered green fields and a wide, blue river that reminded them of their homeland. The land across that river would become the town of Essex. Plans for the new subdivision were laid out in 1908 and advertised for sale in 1909 as "The Rising Suburb of the East." The small town soon grew with the addition of a general store, a school, and several churches.

Early in its history, however, Essex suffered the embarrassment of the construction of a large sewer treatment plant just to its west across the river. The Back River facility, owned and operated by Baltimore City, almost immediately put a stigma on the fledgling community. Progress continued nevertheless, with the area becoming known as a summer resort and waterfront playground, complete with amusement parks, picnic groves, beaches, and dance halls, the most famous of which was Hollywood Park on the eastern shore of Back River. Prospect Park, a race track that accommodated automobiles, motorcycles, and horses over the years, was on the opposite shore. All manner of fishing, boating, waterfowl hunting, and other recreational activities lured sightseers farther east. Still, farmers and small business owners made up the majority of the population of Essex.

Cars and streetcars brought throngs of people to the waterfront in the 1920s. In 1929, Glenn L. Martin rented a car and drove east from the city searching for a site for his aircraft factory. Finding a vast amount of farmland just east of Essex more than welcoming, Martin quietly assembled enough acreage for the plant. In 1929, he opened the Glenn L. Martin Company on 1,200 acres in Middle River. The plant drew thousands of out-of-state workers who found steady employment at Martin's and housing in both Essex and Middle River. As the plant gained contracts to build airplanes, the workforce grew until reaching a peak of 54,000 in the war years.

Following the war's end, Martin was forced to downsize, but somewhat unexpectedly, people who had moved to the area to find employment at the plant decided to stay. Charmed by the countryside and intrigued by the nearby city life, the settlers soon found other jobs.

The Essex fire of 1957 damaged not only the 500 block of Eastern Avenue but the economy and pride of the area as well. The construction of shopping malls at Eastpoint and Golden Ring soon turned the Essex business district into a ghost town. Sewer plant failures were frequent in the 1970s and 1980s, further exacerbating the community's problems. Employment and property values continued to decline into the 1990s as industry began to disappear.

Revitalization plans introduced by the Baltimore County government and the Essex Development Corporation in the 1970s gained steam at first then failed to materialize when county funding ran out. Aging apartment complexes built to house the wartime workers drew subsidized and low-income housing, and the feeling of being dumped upon frequently was expressed by Essex residents. Thousands of tenants added to overcrowded school conditions while deteriorating roads and infrastructure were neglected in the once rising suburb turned low-income refuge.

The community began to receive help from the government in the 1990s when a streetscape was proposed for Eastern Boulevard, and old apartment buildings were razed. Residents, burned by the lack of jobs and influx of subsidies, were suspicious of government motives, however, and many resisted change. They found their suspicions justified in 2000 when the state and local government swooped down with a condemnation-for-revitalization bill known as SB 509. The county and state wanted to condemn business and residential property, pay market rate to owners, give their land to developers, and allow them to construct multi-million-dollar private projects. Outraged citizens of Essex and Middle River rebelled, lobbied their state legislature in Annapolis by the busload, and mounted a referendum drive and political campaign that defeated the condemnation law by a 70 percent majority.

Government officials never did officially apologize to targeted property owners but conceded that they went about revitalization the wrong way. The next administration, led by County Executive James Smith, resumed the revitalization by offering the community increased opportunity for input. The streetscape finally went forward, more decaying war-era apartments were demolished and successfully redeveloped, and while some business owners in the revitalization area sold their property and moved their businesses, others determined that it would be more beneficial to remain and expand.

Today all roads leading to Essex, especially the extension of Maryland Route 43, seem paved with gold, and recent sales show properties with modest shore homes selling for well over a half million dollars. While some old-timers feel squeezed out by the massive scale of new development and worry whether they will be able to afford to pay their escalating property taxes, most new and old residents are enjoying the renaissance of their hometown. And Essex, once again, is living up to its old sales slogan as "The Rising Suburb of the East."

One

THE EARLY YEARS
From Bridge to Bridge

BACK RIVER BRIDGE, 1930S. The original, wooden Back River Bridge, built in 1877, was replaced in the 1890s by an arched, steel-girdered structure with a draw in the center that allowed boats to pass to and from Northeast Creek. Rail service was instituted around 1895 to transport city residents to amusement parks and picnic beaches in rural areas to the east. Such transit opened the way for the development of Essex in 1909. (Courtesy Mary Pospisil.)

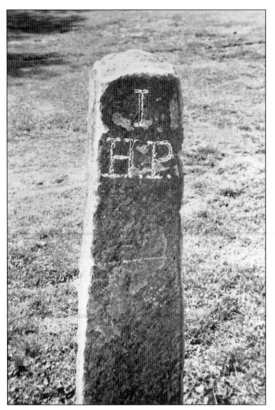

HISTORIC MONUMENT. This granite marker once stood at the corner of Mace and Franklin Avenues where it was placed in 1798 as a result of a boundary dispute, according to records of the Heritage Society of Essex and Middle River. The land where it stood was named Hines Purchase in recognition of owner Thomas Hines. The marker is now located at the Heritage Society Museum at 516 Eastern Boulevard in downtown Essex. Another stands in front of Essex Elementary School on Mace Avenue.

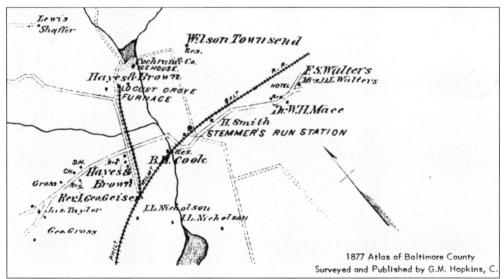

ROSSVILLE P. O. A map from the 1877 Atlas of Baltimore County shows the area served by the Rossville Post Office. In 1909, much of that land would be divided into parcels, marketed and sold as "Essex, the Rising Suburb of the East." The 1877 atlas was surveyed and published by G. M. Hopkins. (Courtesy Baltimore County Public Library.)

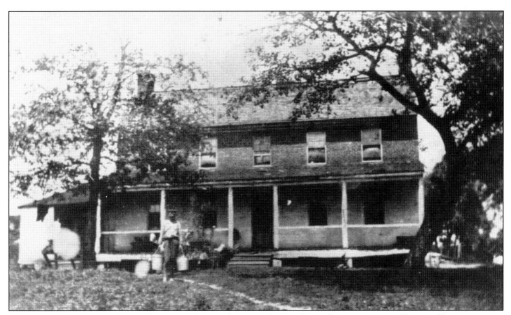

PARADISE FARM. In the mid-1800s, the Taylor family purchased 1,700 acres of low, rolling country with a beautiful river by its side and named it Paradise. The Paradise farmhouse, shown in the early 1900s, was occupied by tenant farmers, members of the Tutchton family, from 1860 until 1923. In 1908, most of the farm was subdivided to create building lots for the new town of Essex. (Courtesy Iva Tutchton Ikena.)

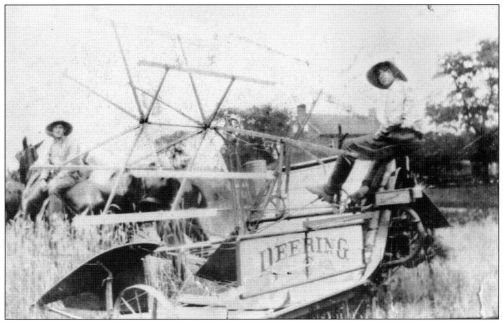

HARVESTING GRAIN. Autumn was a busy season at Paradise Farm, shown in the early 1900s. A Deering grain binder was used to cut the stalks close to the ground and tie them into bundles. The bundles later were pitched onto bundle racks and hauled to the threshing machine, which separated chaff and straw from grain. Timber from the farm was cut and transported to the Taylor sawmill at Eastern and Taylor Avenues. (Courtesy Iva Tutchton Ikena.)

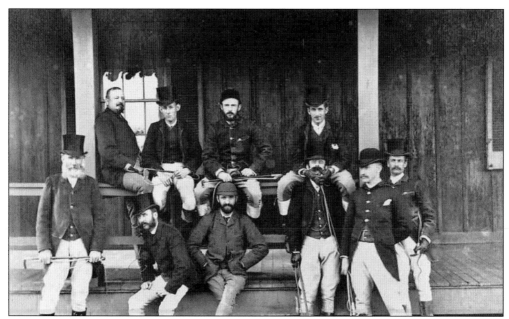

FOX HUNTING. Pictured in 1883 at George S. Brown's ducking club on Back River, in the area of today's Essex Skypark, are members of Elkridge Hunt Club. Pictured from left to right are (first row) George S. Brown, Cary McHenry, unidentified, Fred Shriver, Frank S. Hambleton, and Joseph H. Voss; (second row) John Gill, Harry Harwood, Alexander Brown, and T. Swann Latrobe. The Browns ran the prosperous Baltimore banking company Alex. Brown and Sons.

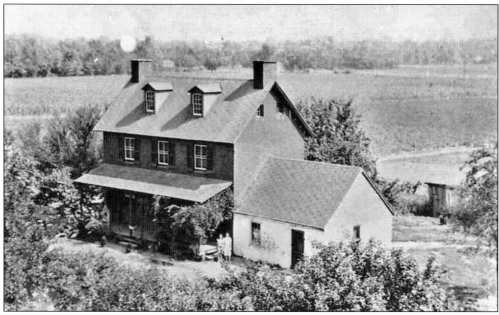

SOMOGYI FARM. The farmland surrounding what is now called Somogyi Lane on Back River Neck was part of the early-1900s holdings of the Schluderburgs, who were partners with the Kurdle family in ownership of Baltimore's Esskay Meat Company. There they fattened up cattle for slaughter. The old farmhouse, said to date back to the late 1700s, has changed hands many times and was purchased in 1923 by Louis and Marie Somogyi, whose descendants still live there.

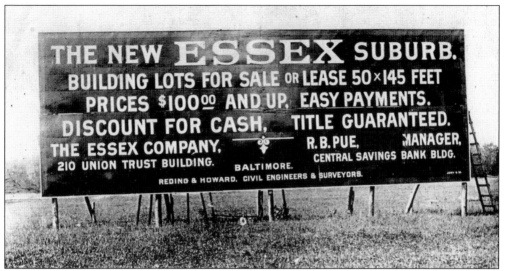

LAND SALES. The opening day of lot sales in Essex was June 26, 1909, with "agents on the grounds every day from 2 p.m. until dark," according to sales advertisements. Under the management of R. B. Pue and operating out of a small office at the corner of Taylor Avenue, the company sold home sites for as little as $5 down and $5 per month. (Courtesy Heritage Society of Essex and Middle River.)

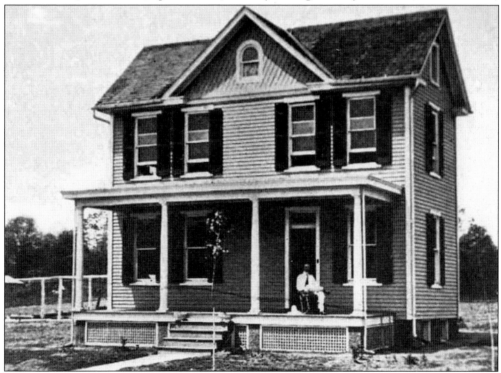

FIRST HOUSE. This two-story frame home known as the Schuster House is located at the corner of Dorsey and Taylor Avenues. The photograph is dated 1909, the year the Taylor Land Company began selling lots in Essex. The house was owned originally by Mr. and Mrs. John Schuster and is purported to be the first home built in the new subdivision of Essex. (Courtesy Heritage Society of Essex and Middle River.)

GUTTENBERGER'S STORE. The first business established in Essex was Henry Guttenberger's general store, located at the corner of Eastern and Mace Avenues, shown in 1910 and again below as expanded in 1920. It opened its doors in 1910 and soon became the area's popular grocery store, post office, and gathering place. (Courtesy Heritage Society of Essex and Middle River.)

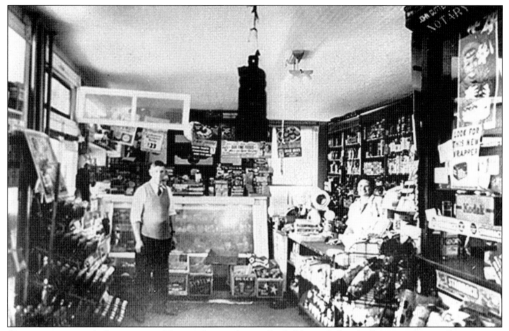

GUTTENBERGER'S INTERIOR. Henry Guttenberger's children, John and Anna Guttenberger, ran the general store at 400 Eastern Avenue and lived there for many years. John Guttenberger is shown standing at left while his sister, Anna, is behind the counter. (Courtesy Baltimore County Public Library.)

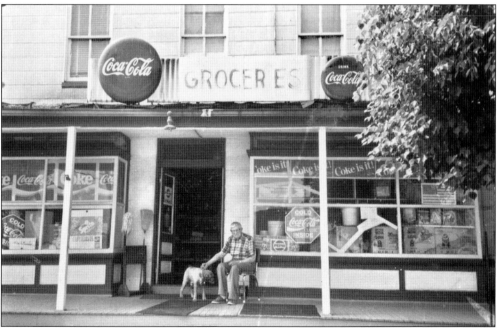

JOHN GUTTENBERGER. Pictured during an Essex Day community festival in the early 1990s, John Guttenberger continued to operate the grocery store at the corner of Eastern and Mace Avenues until a few years before his death in 1995. Seated with his dog on the wide front porch of the now-restored building, he was a familiar scene to passersby. (Author photograph.)

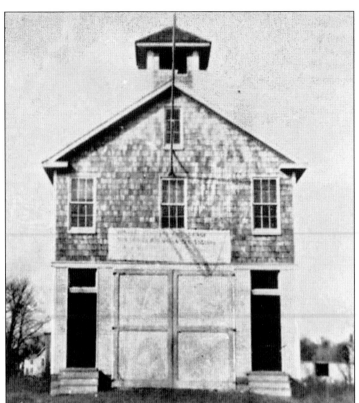

FIRST FIREHOUSE. The original home of the Vigilant Volunteer Fire Department was a frame structure with a prominent tower built in the 500 block Eastern Avenue on land donated by the Taylor Land Company. Construction began in 1914, and the new firehouse was dedicated in 1915. The building later housed the Vigilant Federal Savings Bank. (Courtesy Heritage Society of Essex and Middle River.)

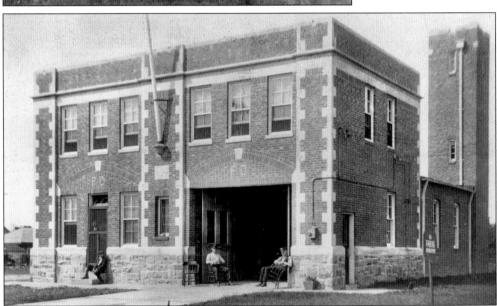

NEW STATION, 1920s. The new Essex police department and fire station, two buildings under one roof, were designed by architect G. Walter Tovell and constructed in 1921. In 1975, the building was turned over to the Heritage Society of Essex and Middle River for its use as a nonprofit museum and meeting place that is open for tours most Sundays from 1:00 p.m. to 4:00 p.m. (Courtesy Heritage Society of Essex and Middle River.)

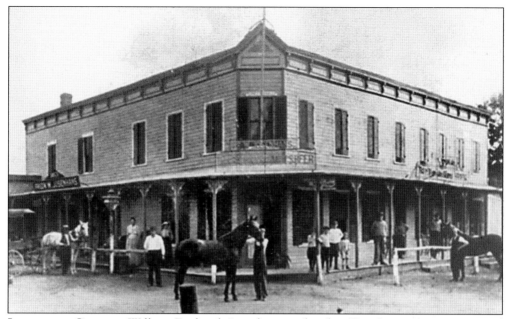

JOSENHANS CORNER. William Frederick Josenhans wed widow Kate Lauenstein in 1907 and around the same time purchased Walters general store and tavern at Eastern Avenue and Back River Neck Road. He soon installed a new sign proclaiming "Wm. Fred'k Josenhans" with the store's logo, a beehive with the words "The Beehive of Industry." The expanding family lived on the second floor and in some rooms at the back of the store. (Courtesy *Avenue News.*)

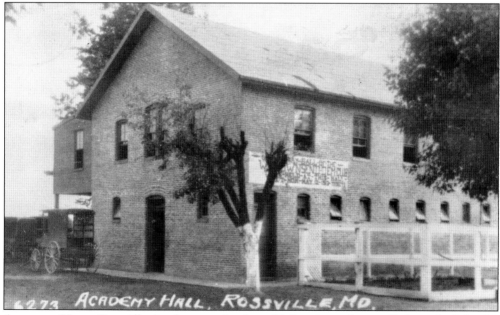

ACADEMY HALL. Rossville Academy, or Academy Hall as it was later called, was built by the Josenhans family in 1912. Located behind the general store, the 30-by-50-foot building consisted of a ground-floor stable for horses whose owners attended social functions upstairs. In the wood-floor hall, guests enjoyed dances and town meetings. The building also was the home of the first Democratic Club in Baltimore County. (Courtesy *Avenue News.*)

CONSTABLE WOOD. James W. Wood, whose family members had a farm at Rocky Point, became the Rossville, later Essex, area's first police constable in 1898. He drove from Bengies-Chase by horse and buggy to Josenhans Corner where a streetcar took him to his post in Canton or Towson. Wood even used the streetcar to transport his prisoners to jail. In 1903, Wood was shot and injured by a woman he had arrested over a property dispute. (Courtesy Page family.)

WEBER'S BEER GARDEN. Daniel Weber came to Baltimore from Germany, settling in Germantown (now Highlandtown) in the late 1800s. Around 1900, Daniel purchased a saloon at the northwest corner of Eastern Avenue at the intersection of Back River Neck Road. He wed Barbara Porter, and the couple lived upstairs while running their popular tavern and beer garden. (Courtesy Daniel Weber Hubers.)

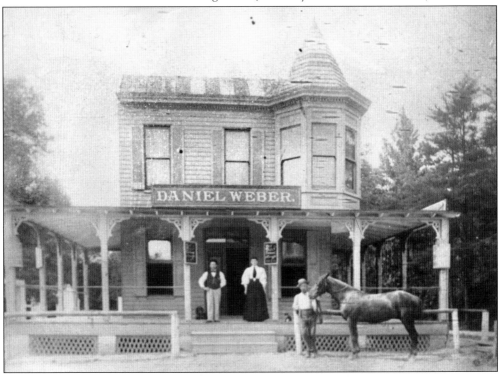

Dr. Carville Mace. Although several members of the Mace family were physicians in earlier years, Dr. Carville Mace was the primary physician of Essex residents in the 1920s. His estate, known as the Echoes, was located in Rossville on the current site of Franklin Square Hospital Center and Essex Community College. The large L-shaped home was demolished in 1968 to make way for new construction. (Courtesy Daniel Weber Hubers.)

Three Playmates. Teddy (left) and Albert Mace (center) were the sons of the famous Dr. Carville Mace of Rossville, who served the entire Essex area in the early 1900s. Shown in the early 1920s, they often visited Daniel Hubers (right), grandson of Daniel Weber, at the Weber family home. It was the Mace boys' father who brought young Dan into the world. (Courtesy Daniel Weber Hubers.)

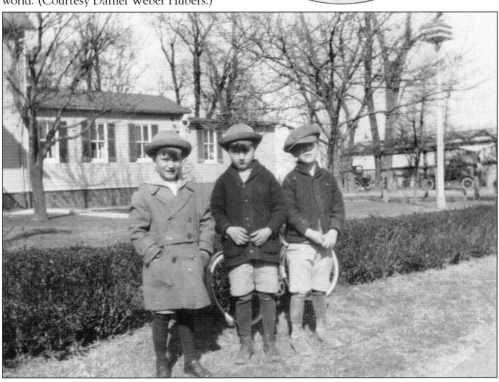

HOLLYWOOD PARK. A newspaper advertisement from the *Baltimore Sun* and a detail from a 1911 editorial cartoon are mere hints of the attractions that drew thousands to the shores of Back River from the time Hollywood Park was built in 1895 until it burned down in 1921. Famous vaudevillians performed on a stage in a hall that could accommodate 3,000, while coatless waiters hustled to serve schooners of beer and legendary soft crab sandwiches to a multitudes of noisy visitors, as described by *Baltimore Sun* icon H. L. Mencken. Mencken related that the male waiters were tough, fit, and outspoken, expressing no deference to their customers and addressing them as equals. The sound of cracking crab shells in the hall was "like a wagon running over soda crackers," Mencken wrote. Outside the pavilions, revelers enjoyed two roller coasters, a carousel, shooting gallery, and some tamer amusements.

STREETCAR BARN. The United Railway and Electric Company streetcar barn was at Eastern and Moffitt Avenues. The huge structure was used as a storage building for streetcars in the early years of public transportation in Essex. Old-timers recall the building also was the nesting place for a huge population of bats. The site is now part of the Back River Wastewater Treatment Plant. (Courtesy Heritage Society of Essex and Middle River.)

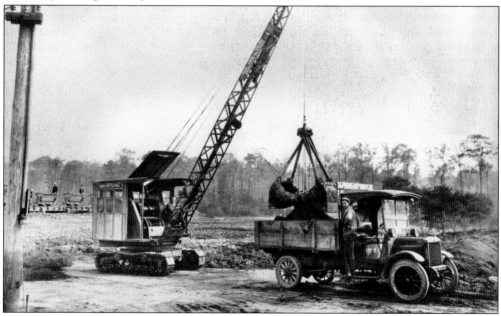

WASTEWATER TREATMENT PLANT. Workers at the Baltimore City–owned Back River sewage treatment plant used a locomotive crane to load sludge into a farmer's truck in this photograph dated May 5, 1927. Much to the chagrin of residents of the new town of Essex, on the other side of Back River Bridge, the oft-malodorous sewage treatment facility began operations in 1911. (Courtesy *Avenue News.*)

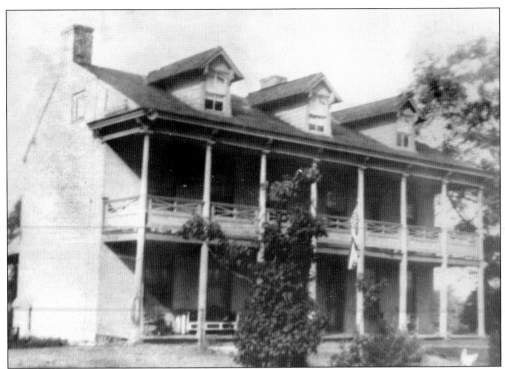

PRESERVATION EFFORTS. The Ballestone-Stansbury House, shown in front and rear views, had fallen into disrepair in the mid-1900s. In 1969, the historic home was purchased and rescued by Baltimore County Department of Recreation and Parks and was rebuilt with public and private funds. It opened for tours in 1977 and continues to host special events today. Members of the Ballestone Preservation Society care for the home under the auspices of the Baltimore County Department of Recreation and Parks. (Courtesy *Avenue News*.)

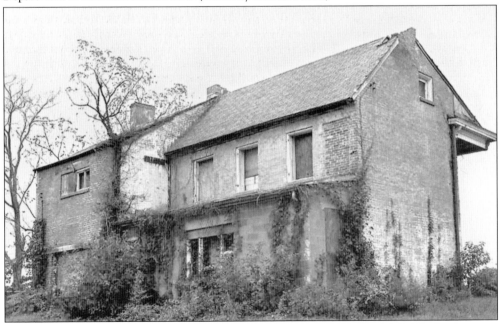

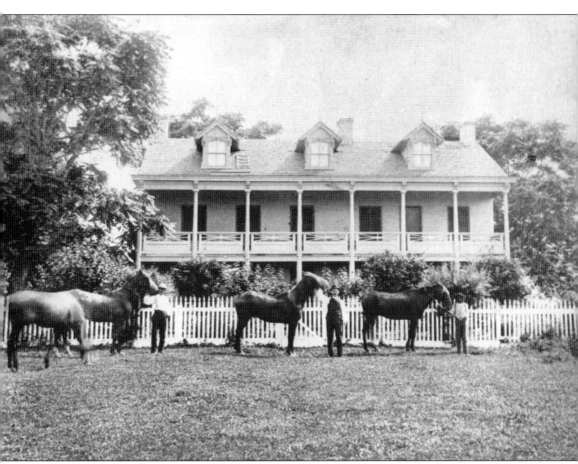

BALLESTONE-STANSBURY HOUSE. Three spits of land at the very end of Back River Neck Peninsula are identified on maps from the 1800s as Balliston Point, Rocky Point, and Cedar Point. Jutting into Browns Cove, Hawk Cove, and Back River, the peninsula in its early days saw a smattering of truck farmers and fishermen, as well as summer boaters and winter hunters. The farmhouse at Cedar Point, shown, was the most substantial area dwelling of its day and is said to have been constructed between 1798 and 1813 of brick transported as ballast in the hold of English ships. The ground on which the home is situated is referred to in old land records as "Stansbury's Claim" or "Dickenson." Members of the Stansbury family were the first to occupy the land that was purchased in the mid-1800s by Edward Miller. Well into the 1900s, the home was owned by the Miller family, some of whom are shown in the *c.* 1900 photograph with their horses. (Courtesy Ballestone Preservation Society.)

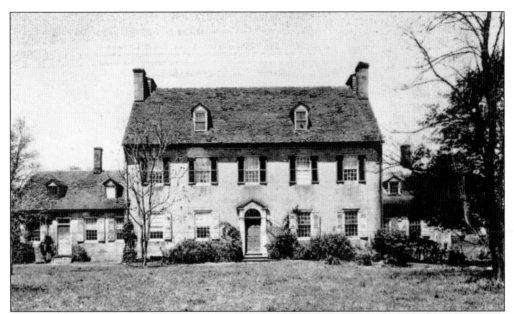

STEMMER HOUSE. In the mid-1700s, a large, brick house was built in Rossville for ironmasters of the Principio Company. In 1793, the property was purchased by Capt. Ullrich Stammer, a privateer who purportedly hid his ships in the Stemmers Run waterway near the dwelling. The house, moved brick by brick in the 1920s to Caves Road, is pictured in the late 1890s. (Courtesy Historical Society of Baltimore County.)

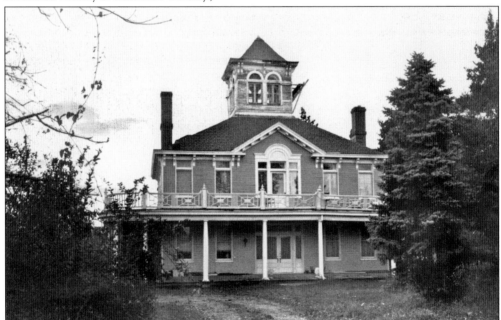

BAUERNSCHMIDT MANOR. Once owned by philanthropist Enoch Pratt and used as a hunting club, the site of the manor was purchased in 1904 by well-known Baltimore brewer Frederick Bauernschmidt. Bauernschmidt and his wife, who built the house in 1910, lived there during the summer months and hosted annual crab feasts for brewery workers on the property. (Courtesy *Avenue News*.)

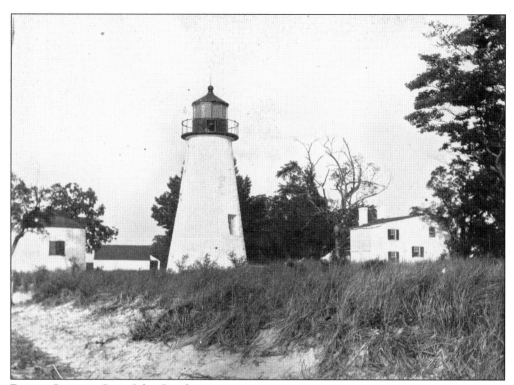

POOLES ISLAND. Capt. John Smith was probably the first Englishman to set foot on Pooles Island, which is named for a member of his exploration crew, Nathaniel Powell. During the War of 1812, British troops occupied the isle, feeding their troops from its wildlife and crops while setting up a gun battery there. In 1825, a lighthouse was built, and in 1873, a peach orchard was added. Birds and wildlife, including deer, heron, and bald eagles, flourished there. During World War I, the federal government annexed Pooles Island, shown in the 1920s, as part of the U.S. Army Proving Ground. Armament was tested there, and an observation tower was constructed near the lighthouse, which is the oldest in Maryland. Anton Hubers, right, a friend of an early lighthouse keeper named Cohee, was among those who hunted on Pooles Island. (Courtesy Daniel Weber Hubers.)

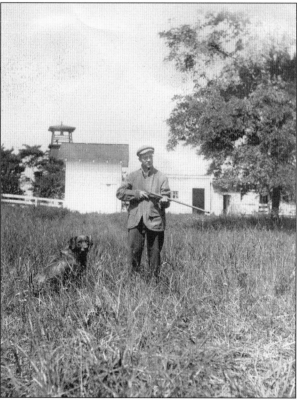

HISTORY OF ESSEX—PAST AND PRESENT.
1750—1908.

Along the beautiful shores of Back River lies the Paradise Farm. There stands the old colonial farmhouse, built a century and a half ago of hand-made bricks brought from England. Paradise Farm was originally a large tract of 1700 acres, and was owned by Mr. Taylor. In 1870 Mr. Tuchton rented this farm and lived there until his death last spring. Much of the farm was then in woodland and the only way to the outside world was a woods road which went around the head of Middle River. Seven years later a wooden bridge was built across Back River and the present road made· The bridge has been replaced by a fine concrete structure.

Forty years ago a club house was opened at Cove's Point and is still a pleasure resort. Paradise Farm itself once had a club house. Ten years after Cove Point opened land was sold for the colored church, and a store was built; this store is now known as Josenhan's.

In 1895 the trolley company extended its tracks into this part of the country. At first the terminal was Back River, but a little later it went on down as far as Josenhan's.

Fifteen years ago Mt. Carmel Catholic Church was built and in the same year Hollywood Park was opened and has continued to be a popular resort. In 1908 Chesaco Park was built and houses began to go up quickly in that vicinity. Little by little Paradise Farm has been sold, until now it is only a few acres. In 1909 the Taylor Land Company laid off building lots and in the same year Mrs. Shuster's house was built, the first in Essex. A few months later Mr. Henry Guttenberger opened a grocery and general merchandise store. The next year more dwellings were erected, more land cleared, and more people were attracted to this part of the country.

In January, 1913, the public school opened in a bungalow built for the office of the Essex Company. This school had twenty-eight pupils. The following summer the Lutheran and Methodist churches were begun; these churches were dedicated in the fall. And so Essex grows—more stores are being opened, more land sold, more people seeking homes in the country. There is little of history yet to write, for the town is in its infancy; but we shall watch its growth with interest and see its history as it is being made. *Catharine Jackson.*

RECORDED HISTORY. In 1917, Isobel Davidson, supervisor of primary grades of Baltimore County Schools, coordinated publication of a hardcover book, *Real Stories from Baltimore County History.* Data was collected from both teachers and children of the county schools to reflect the area's heritage in a more colorful and interesting way in contrast to the often dry history that pupils back then were required to read. The portion on Essex by Catharine Jackson, presumably a teacher, is short yet descriptive, taking up only one page of the 282-page book printed by Warwick and York Company of Baltimore. (Courtesy Bruzdzinski family.)

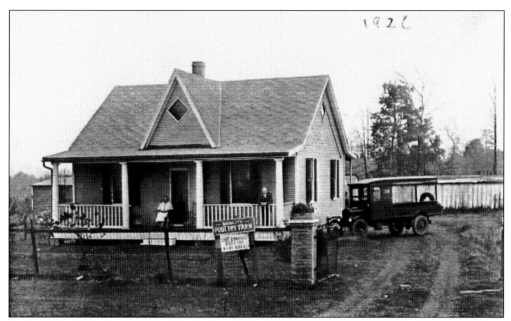

MATEJKA QUALITY POULTRY FARM. Alzbeta and Jaroslav "Jerry" Matejka are shown in this 1926 photograph on the porch of the home and business they built on Eastern Avenue Road in 1916. While working as a tailor creating custom-made suits, Jerry Matejka also built up a poultry business, which in 1924 became a full-time operation. Matejka's Quality Poultry Farm provided live and dressed poultry to scores of market customers. (Courtesy Slava Matejka Mowll.)

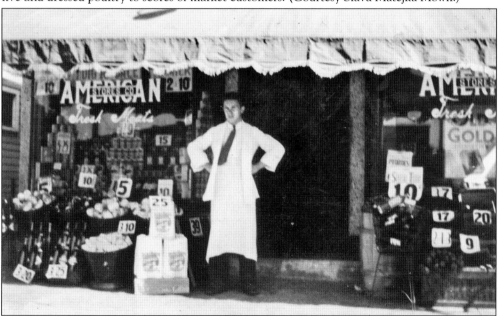

AMERICAN STORE. In the late 1920s at age 14, Henry Oldewurtel began working at a small chain store on Eastern Avenue near Riverside Drive known as J. W. Crook's. The grocery and produce store, with its colorful awning and display of fruits and vegetables, soon changed hands and became the American Store. Henry later became meat department manager at the A&P supermarket in the 500 block of Eastern Avenue. (Courtesy Henry Oldewurtel.)

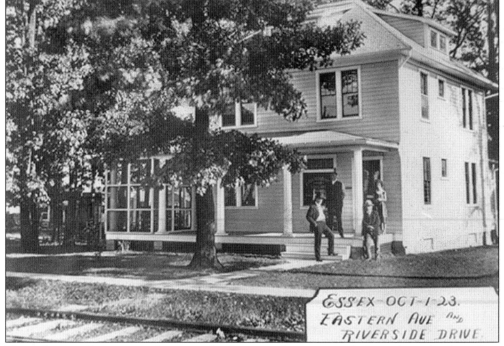

MAIN STREET. Streetcar tracks are in the foreground, just a stone's throw from the front door of a three-story frame house located at Eastern Avenue and Riverside Drive. The single-track car line ran along the south side of the main thoroughfare as shown in this photograph dated October 1, 1923. (Courtesy Heritage Society of Essex and Middle River.)

OLD BARN. This large barn, once located in the Stemmers Run Road area, was owned by the family of Doris L. Gross, an early librarian of the Middle River Library. Gross had a long and distinguished career as an educator and was instrumental in the development of the county's library system in the Essex–Middle River area. (Courtesy Baltimore County Public Library.)

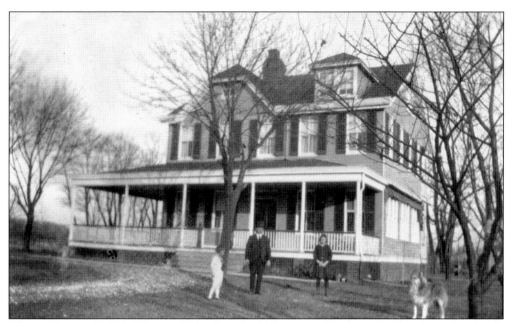

WEBER HOUSE. In 1906, Daniel Weber bought 100 acres on Hopkins Creek, moving his family into a substantial home on the land. He cleared the shorefront, dragging tree trunks by horse and wagon to a sawmill erected in a barn on the property. There the lumber was milled and used to construct small cottages along the water's edge. These shore houses became rental properties enjoyed by city folks escaping the summer heat.

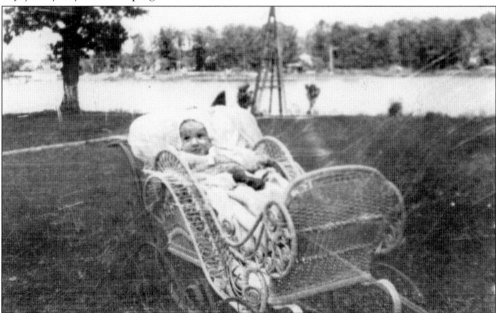

DANIEL WEBER HUBERS. Shown in 1918 in a wicker perambulator with Middle River in the background, Daniel Weber Hubers is the grandson of Daniel Weber, who was founder of Back and Middle River Building and Loan Company. His mother and father, Anna and Anton Hubers, settled on a large piece of property in a stately home on Weber Avenue off what is now Old Eastern Avenue. (Courtesy Daniel Weber Hubers.)

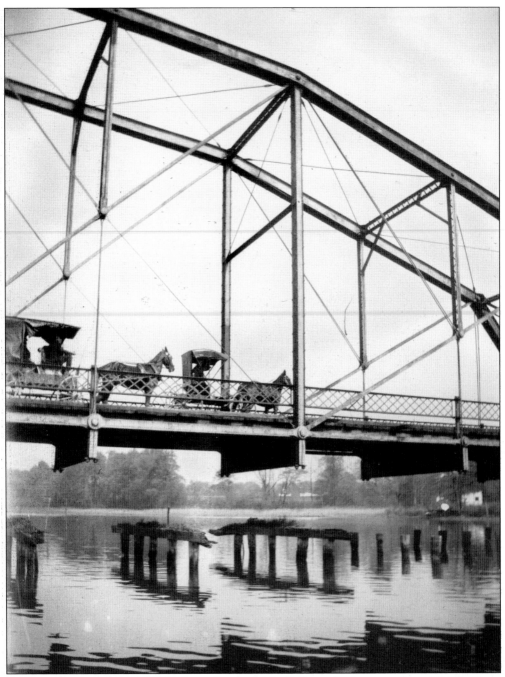

MIDDLE RIVER BRIDGE. While Essex begins at Back River Bridge, it ends at Middle River Bridge, pictured providing a crossing for horse carriages *c.* 1900. Arched steel girders spanned the structure that took the place of an old, wooden bridge whose decaying pilings can still be seen in the photograph. The bridge led visitors from the end of the Eastern Avenue trolley line across the headwaters of Middle River toward farms, shores, and fishing shacks farther east. The position of the old bridge was at a northeast angle as compared to the present span. (Courtesy Daniel Weber Hubers.)

Two

SCHOOLS, CHURCHES, TRANSPORTATION, AND PUBLIC SERVICES

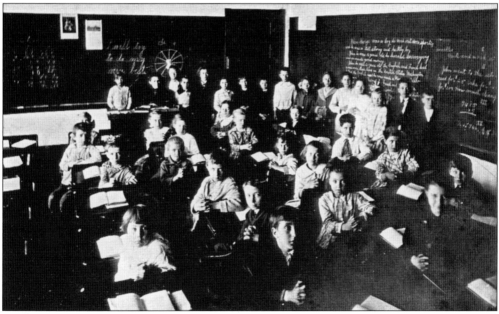

ESSEX PUPILS. Miss Morgan's fourth-grade classroom at the second Essex School is shown in this 1919 photograph, with student Jerry Matejka standing second from the right. Miss Branford Gist was the Dorsey Avenue school's principal, having moved with the school from its first location at Eastern and Taylor Avenues. The reconstructed site today is the home of the busy Essex Senior Center. (Courtesy Slava Matejka Mowll.)

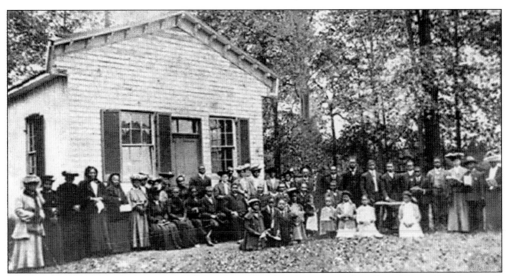

ST. STEPHEN'S A.M.E. CHURCH. The oldest African American church in Essex, St. Stephen's African Methodist Episcopal Church, began its ministry in the 1870s. The top photograph shows the first St. Stephen's A.M.E., a log building covered with siding, with the minister and congregation gathered outside. After being destroyed by fire, the structure was replaced in 1907 with the wood-frame church pictured below. St. Stephen's was rebuilt a third time in 1972 and further expanded in later years. The church continues its ministry at 1600 Old Eastern Avenue at the intersection of Back River Neck and Stemmers Run Roads. (Courtesy Baltimore County Public Library.)

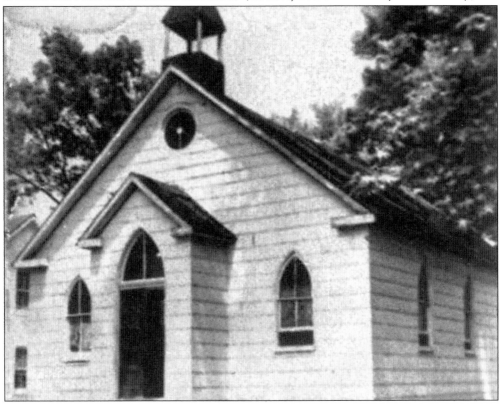

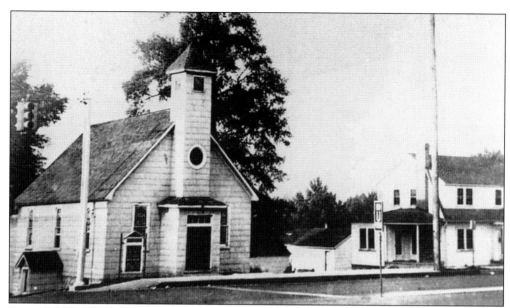

ESSEX UMC. The first Methodist church in Essex was launched at a tent revival held at Mace and Dorsey Avenues by residents who had been conducting services in their homes. Essex United Methodist Church was incorporated in June 1913, and soon thereafter, construction of a building was underway at the southwest corner of Eastern and Taylor Avenues. The church later relocated to Maryland Avenue. (Courtesy Heritage Society of Essex and Middle River.)

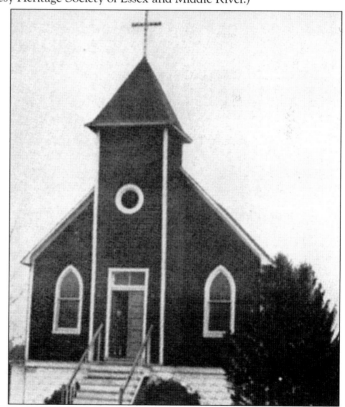

ST. JOHN'S. Known in the early days as "the little brown church," St. John's Evangelical Lutheran was established in 1913 with the laying of a cornerstone at Franklin Avenue on land donated by the Taylor Land Company. The church was dedicated in May 1914 with Rev. C. F. W. Hartlage as pastor. In 1929, Rev. Leo Tecklenberg became pastor; he continued to serve for 50 years. (Courtesy Heritage Society of Essex and Middle River.)

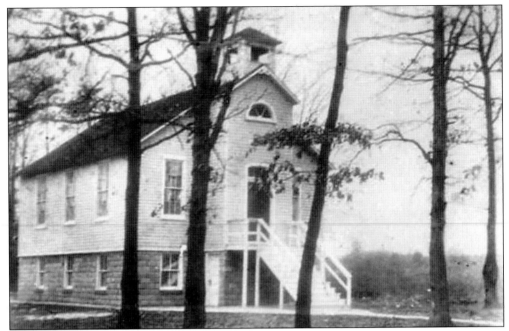

BACK RIVER CHURCH. The first Back River United Methodist Church was built in 1888 on land donated by Elisha Hughes with timber furnished by the Vollmer family of Holly Neck. It has undergone several renovations, including elevation and the addition of a basement, as shown in this picture, following a devastating fire in the late 1920s. (Courtesy Heritage Society of Essex and Middle River.)

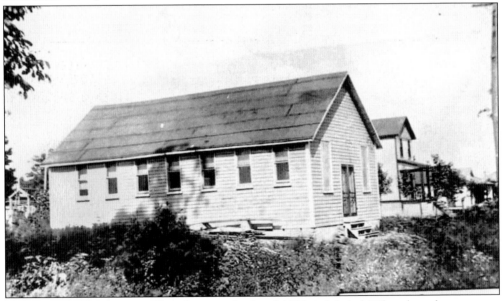

CHURCH AND COTTAGES. This photograph, dated 1923, is labeled "Church and cottages at Riverside Drive and Maryland Avenue in Essex." According to longtime Essex residents, it was known only as Hollinger's Church for its pastor, Reverend Hollinger, who operated a small grocery store and lived next door. The church later ministered to a Presbyterian congregation. (Courtesy Baltimore County Public Library.)

MOUNT CARMEL. Our Lady of Mount Carmel Roman Catholic Church's first building, constructed in 1893, is shown in this 1907 photograph. Rev. Charles Warren Currier, pastor of St. Joseph's Parish, Fullerton, served also as first pastor of OLMC. The church was dedicated by James Cardinal Gibbons on October 22, 1893. (Courtesy OLMC 100th Anniversary Committee.)

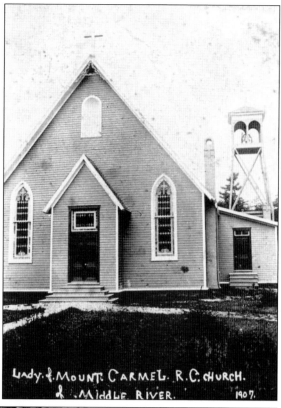

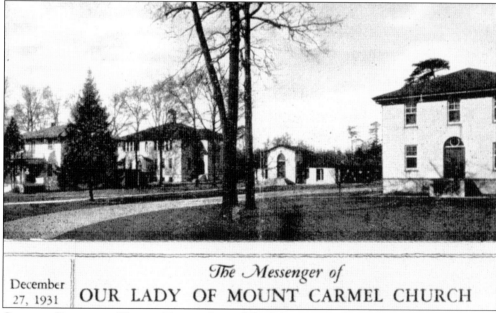

CHURCH BULLETIN. The weekly newsletter "The Messenger" of Our Lady of Mount Carmel Roman Catholic Church shows the expanded parish facility in 1931. The parish had added an elementary school, convent, and rectory to serve the growing staff and congregation. (Courtesy OLMC 100th Anniversary Committee.)

ST. JOHN'S "MESSENGER." An advertising page from the St. John's Lutheran Church "Messenger" of May 1938 is a reminder of the businesses that were part of the vibrant community in the early days of Essex. (Courtesy JoAnn Weinkam Weiland.)

FIRST ESSEX SCHOOLHOUSE. The first Essex school, located at the corner of Eastern and Taylor Avenues, was opened in January 1913 with 28 pupils in the former office of the Taylor Land Company. In 1915, the classes moved to the basement of Essex Methodist Church, then in 1918 to Dorsey Avenue. In 1925, a new, brick Essex school building opened at Mace and Franklin Avenues. (Courtesy Heritage Society of Essex and Middle River.)

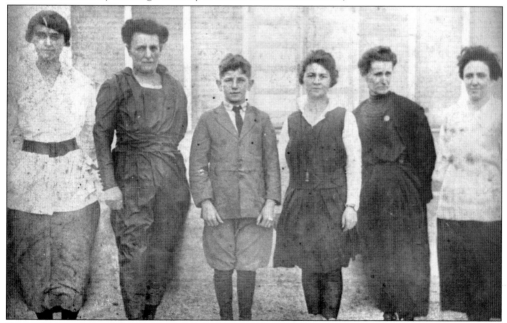

EARLY EDUCATORS. The teachers at Essex Elementary School are shown in this 1919 photograph. In the center is 14-year-old eighth grader Henry Oronson. For 20 days, under the supervision of the principal Miss Branford Gist, young Henry took over the duties of the third- and fourth-grade teacher, Miss Morgan, when she became ill. (Courtesy Heritage Society of Essex and Middle River.)

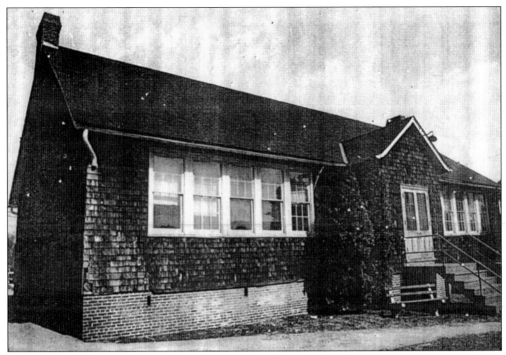

DORSEY AVENUE SCHOOL. In 1918, the Essex primary school, shown in this news clipping, moved into a cedar-shingled building at Dorsey Avenue and Woodward Drive. In the late 1950s, the schoolhouse became the first home of Essex Community College, and the rebuilt structure today is the site of the busy Essex-Dorsey Senior Center. (Courtesy Heritage Society of Essex and Middle River.)

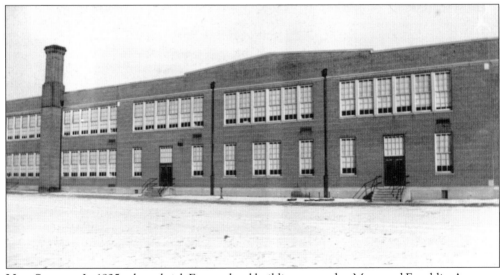

NEW SCHOOL. In 1925, a large brick Essex school building opened at Mace and Franklin Avenues. The modern school and playing fields were set among the roads and houses of a growing Essex. (Courtesy Heritage Society of Essex and Middle River.)

Back River Schoolhouse. The first Back River Neck school, with just two classrooms, is seen in this 1920s-era clipping. Grades one through four were housed in one room and grades five through seven in the other. Water was carried by bucket from a stream not far away, and older pupils eagerly volunteered for firewood and water replenishment duties. The frame structure was heated with two wood-burning stoves, while bathroom facilities were located in two privies behind the building.

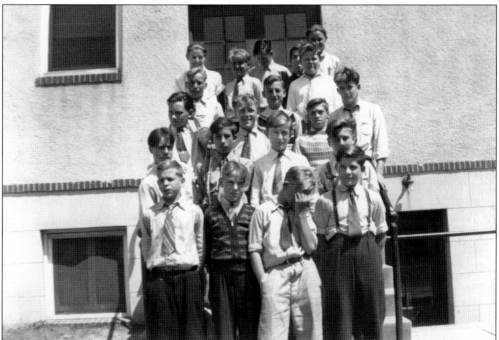

OLMC Class of 1939. A group of graduates comprising Our Lady of Mount Carmel Elementary School's class of 1939 gathered for a portrait on the side steps of the school prior to commencement ceremonies. (Courtesy Heritage Society of Essex and Middle River.)

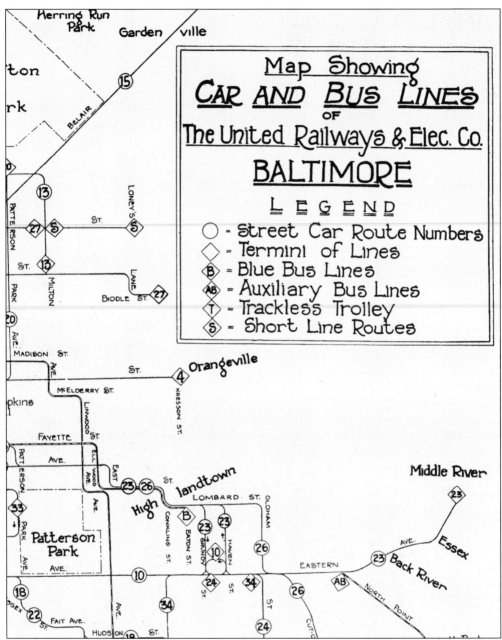

PUBLIC TRANSPORTATION. An early map shows the routes of the United Railways and Electric Company, including car and bus lines, terminals, trackless trolley, and short-line routes, as well as streetcar route numbers. Essex continues today as No. 23 on the Maryland Transit Administration bus line. (Courtesy Dundalk–Patapsco Neck Historical Society.)

TROLLEY STOP. The Back River trolley line 2665 of the United Railways and Electric Company was well known and often crowded with passengers traveling to the famous Hollywood Park. These ladies—Ruby Zoller (left), Theresa Fisher (center), and Mary Hershfield—are pictured in 1907 waiting near a small wooden bridge at a Highlandtown trolley stop. (Courtesy Baltimore County Public Library.)

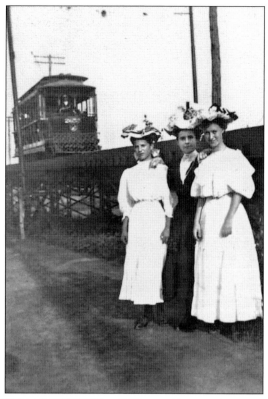

SUMMER CAR. A summer car of the United Railways and Electric Company trolley line brought passengers from Baltimore City to the shores of Back and Middle Rivers. City dwellers flocked to shorefront destinations in these open cars during the early years of Essex. (Courtesy Heritage Society of Essex and Middle River.)

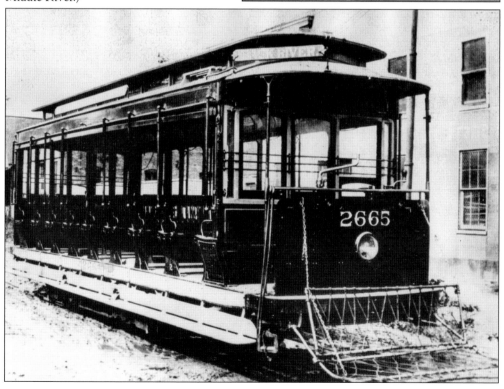

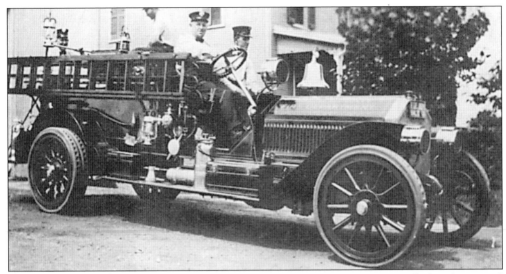

FIRE TRUCK. An early fire truck of the Vigilant Volunteer Fire Company sported a hand-operated bell on the engine hood and wooden ladders mounted to the sides. (Courtesy Heritage Society of Essex and Middle River.)

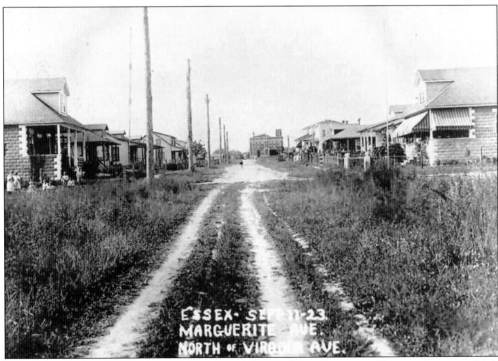

VIEW FROM MARGARET AVENUE. The Essex Police and Fire Station on Eastern Avenue, which was built by G. Walter Tovell in 1921, is shown in the distance. The photographer was positioned in the middle of an unpaved Margaret Avenue, aiming the camera toward Eastern Avenue in 1923. (Courtesy Heritage Society of Essex and Middle River.)

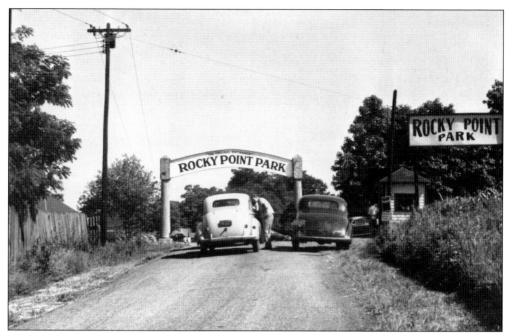

ROCKY POINT. Traffic streamed down Back River Neck to Rocky Point Park on weekends in the mid-1920s. Joseph Porter and his wife, Effie, soon cleared some of their land to make the beach more accessible for swimming and added a picnic pavilion around 1930. Visitors arrived at the park early on summer weekends to secure a picnic table and parking space and clogged the roadway heading home at night. (Courtesy Ray Porter.)

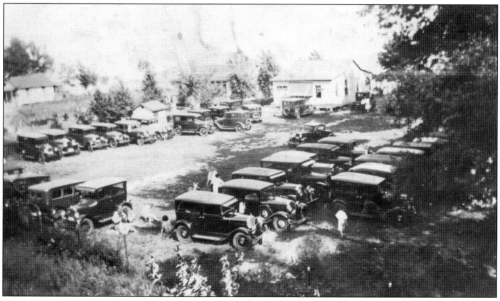

TRAFFIC JAM. Automobiles packed the area at Pospisil's shore on Bay Drive in Bowleys Quarters in 1923. The Pospisils, who also owned a nightclub in Essex, opened 200 feet of bay front to the public as a swimming beach. Mary Pospisil recalls the family transporting food to the shore after closing the Essex nightclub at 2:00 a.m. and attending early Sunday morning mass. (Courtesy Mary Pospisil.)

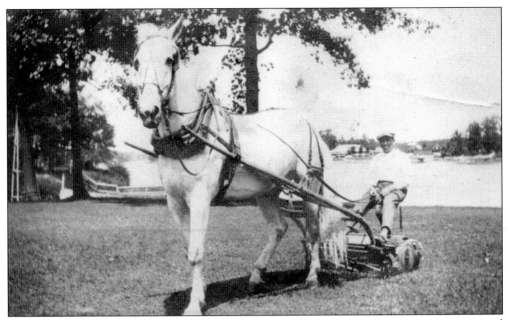

Horse Power. Daniel Weber used this early version of a lawn tractor to manicure grass and keep the Weber Avenue grounds trimmed in the early 1900s. The prominent Essex businessman, founder of Back and Middle River Building and Loan bank, owned about 100 acres off Eastern Avenue (now known as Old Eastern) on Hopkins Creek. (Courtesy Daniel Weber Hubers.)

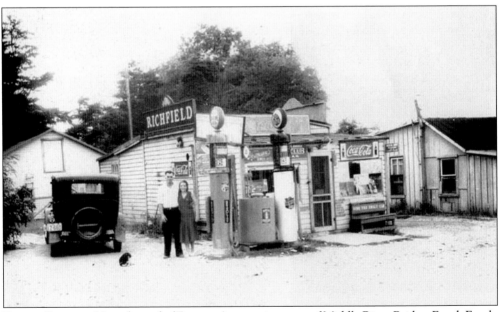

Emala Station. Near the end of Eastern Avenue, just west of Middle River Bridge, Frank Emala Jr. had a gas station, grocery store, bar, and living quarters for his family. He also provided taxi service for those traveling from the streetcar line to the shores farther east. In the late 1930s, he sold the property to the state for the construction of a new roadway. (Courtesy Emala family.)

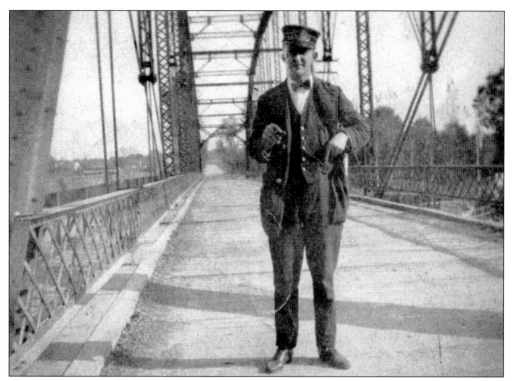

GUARD DUTY. Middle River Bridge was the focus of homeland security measures during World War II. Access to the span was monitored by private security officers, such as this unidentified guard, hired to protect the Glenn L. Martin aircraft factory to the east from possible spy operations or attack. (Courtesy Heritage Society of Essex and Middle River.)

MIDDLE RIVER BRIDGE. An unidentified young woman poses for the camera at the picturesque old Middle River Bridge span in the mid-1940s. The view is looking west toward Essex. (Courtesy *Avenue News*.)

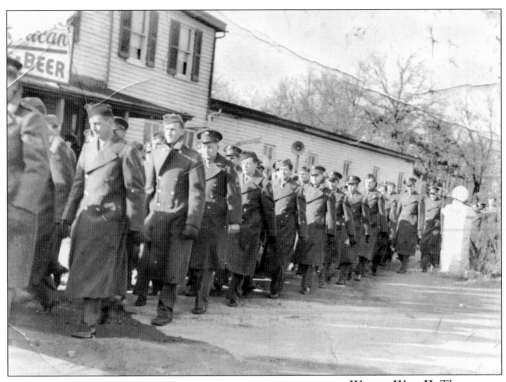

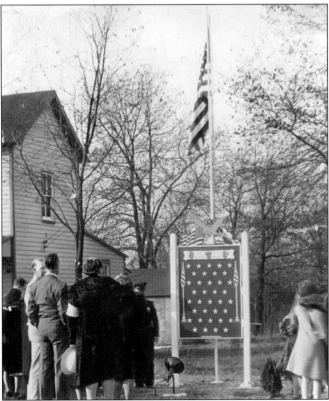

WORLD WAR II. The Pospisil family frequently fed and entertained army boys at their restaurant and catering hall during World War II, as shown in this photograph of a line of soldiers waiting at the entrance in the early 1940s. (Courtesy Mary Pospisil.)

VETERANS MEMORIAL. Services to honor veterans were held outdoors at Pospisil's, where a large memorial plaque was erected. The business owners also helped families in need by providing free meals during the Great Depression. During the Prohibition years, the Pospisils operated a grocery store and provided food for the needy of the community. (Courtesy Mary Pospisil.)

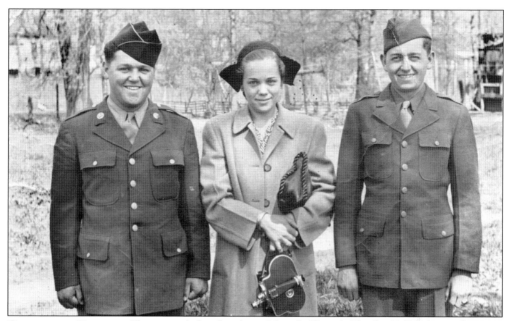

FALKENHAN POSPISIL. Shown with her brothers John (left) and Charles Falkenhan, who were serving in the army during World War II, Mary Falkenhan Pospisil grew up across from Pospisil's tavern. Mary had wanted to go to high school but because of family pressures went to work at age 14 at a tailor shop on Franklin Avenue. She married Albert Pospisil in 1935 and worked in the family tavern business. (Courtesy Mary Pospisil.)

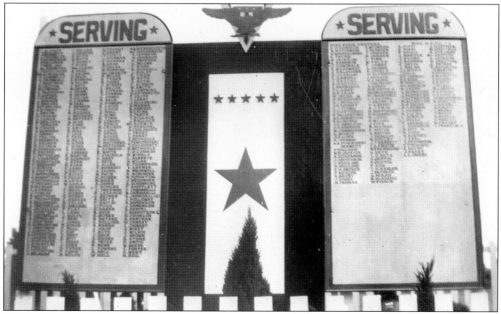

WORLD WAR II MEMORIAL. The first monument dedicated to local servicemen and women was constructed of plywood and painted and lettered by hand beginning in 1943 by John C. Roth. The Essex resident would work late into the night and on weekends adding names and painting gold stars next to those killed in action. The memorial was located at 525 Eastern Avenue. (Courtesy Roth family.)

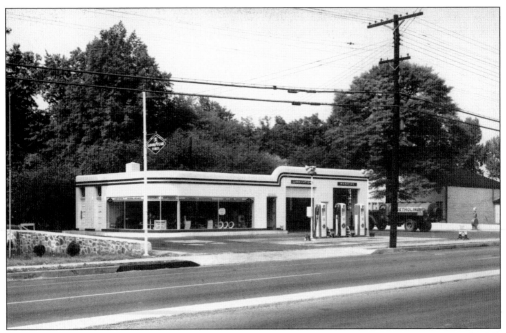

FUEL STOP. In the 1940s, the Pospisils built a service station next door to their tavern and nightclub on Eastern Avenue across from what is now the sewage treatment plant. Betholene was the fuel of choice for many local residents who patronized the gas pumps. (Courtesy Mary Pospisil.)

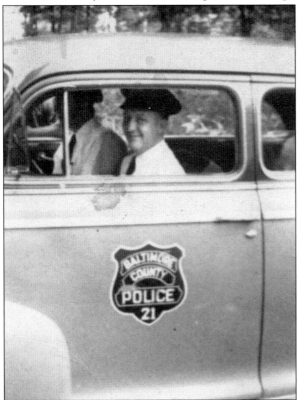

POLICE CAR. Officer William Weinkam is shown in his patrol car outside the Essex station in the late 1940s, when there were only eight officers rotating in noon-to-midnight shifts. He later fulfilled his career as a sergeant in the police department's detective unit in Towson. (Courtesy JoAnn Weinkam Weiland.)

FAMILY OUTING. Members of the Weber-Hubers clan piled into the family car preparing to take a ride on a sunny afternoon in the 1920s. Anna Weber Hubers is behind the wheel. (Courtesy Daniel Weber Hubers.)

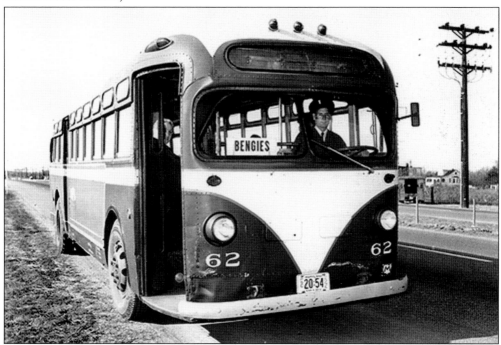

BENGIES BUS. Public transportation eased the way for travelers heading past the far reaches of Essex, heading east down Eastern Avenue to the Bengies area and beyond. The Bengies, Maryland, bus No. 62 with a 1961 license plate is shown in a 1961 Blakeslee-Lane Studio photograph. (Courtesy Baltimore County Public Library.)

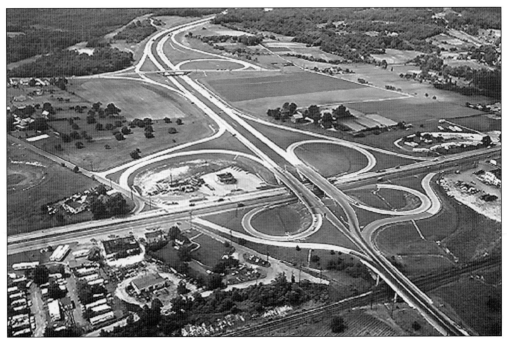

AERIAL VIEW. The Baltimore Beltway I-695 is shown at its intersection with Pulaski Highway shortly after its opening in June 1962. The photographer is credited as Lawrence McNally. (Courtesy Baltimore County Public Library.)

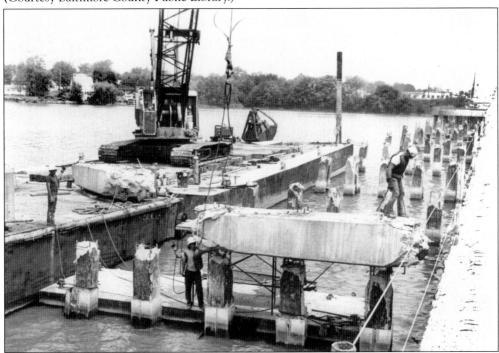

BRIDGE IMPROVEMENTS. Back River Bridge was reconstructed once again in the early 1990s with funds allocated through the Maryland State Highway Administration and additional support from Baltimore County government. (Courtesy *Avenue News*.)

Three

ACTIVITIES, EVENTS, AND ENTERTAINMENT

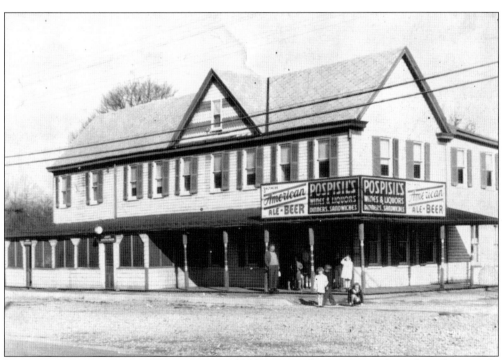

POSPISIL'S TAVERN AND NIGHTCLUB. In 1907, James and Mary Pospisil purchased a wayside tavern on Eastern Avenue west of Back River Bridge. The family lived on the second floor of the popular establishment, which was open seven days a week offering home-cooked meals and floor shows with well-known performers, singers, and comedians. The Pospisils sold the business in 1947, and the building was destroyed by fire 20 years later. (Courtesy Mary Pospisil.)

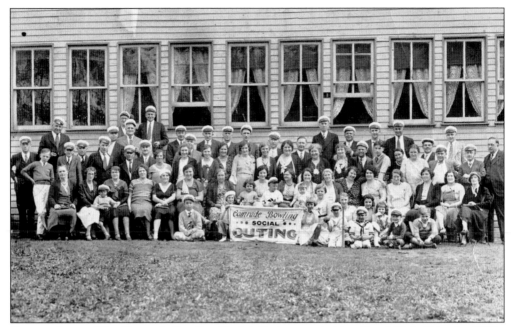

SOCIAL SCENE. The Comrade Bowling Social Outing was held at Pospisil's hall in the 1930s. Political meetings and events, dances, parties, stage shows, and weddings were among the other festivities held in the hall that seated 300–400. (Courtesy Mary Pospisil.)

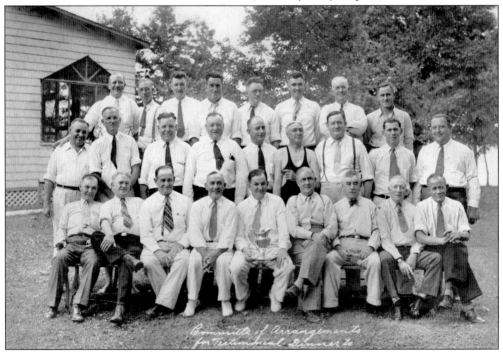

TESTIMONIAL BANQUET. The Committee of Arrangements for a testimonial dinner honoring Essex businessman and political activist Jerry Mueller was held at Pospisil's hall on May 27, 1935. Mueller, shown first row center, owned a hardware store at the corner of Eastern and Mace Avenues. His son, Frank, was a bartender at Pospisil's. (Courtesy Mary Pospisil.)

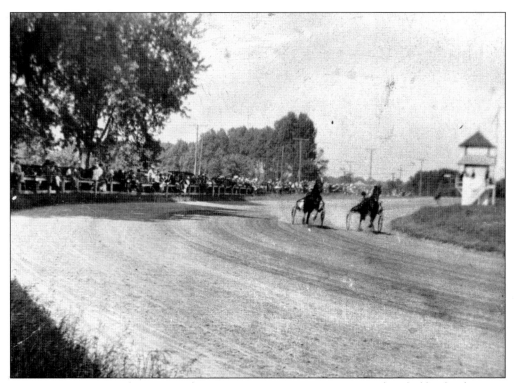

FAST TRACK. Across from Pospisil's on Eastern Avenue, Prospect Park, a half-mile, dirt race track, beckoned visitors. Over the early years, the raceway transitioned from automobile and motorcycle competition to Sunday afternoon sulky races. The park offered other attractions and the popular Prospect Park Fair, which was held for one week each autumn. Late in the 1920s, the land was sold to Baltimore City to provide for expansion of the city-owned sewerage treatment plant. (Courtesy Mary Pospisil.)

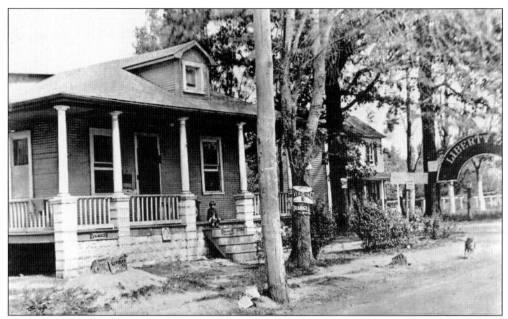

LIBERTY PARK. Along Diamond Point Road, Liberty Park was a pavilion and picnic grove that catered to ethnic and church events and later featured country music. The arched gateway can be seen to the right near Eastern and Oriole Avenues in this 1923 photograph. A baseball park on Oriole Avenue was the scene of Sunday ball games during the days of Baltimore City Blue Laws. (Courtesy Baltimore County Public Library.)

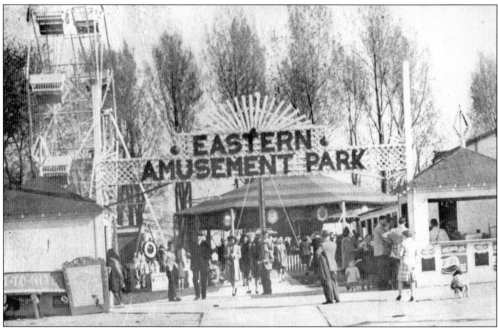

EASTERN AMUSEMENT PARK. On Eastern Avenue not far from Back River Bridge, Eastern Amusement Park offered activities for young and old, including food, music, and picnic grounds along the riverside. The site later housed the Essex Skating Rink and is now the home of Rink Bingo. (Courtesy Heritage Society of Essex and Middle River.)

HARDSHELLS. A group of well-connected Baltimore tavern owners formed a men's club called the Hardshells in August 1935. They held annual crab feasts at the Essex shore home of the "Imperial Jumbo," while other offices were filled by the "Claw" and "Back Fin." After feasting, the men would parade down to the river and set free a live crab to propagate the species for future crab feasts. (Courtesy Nickel family.)

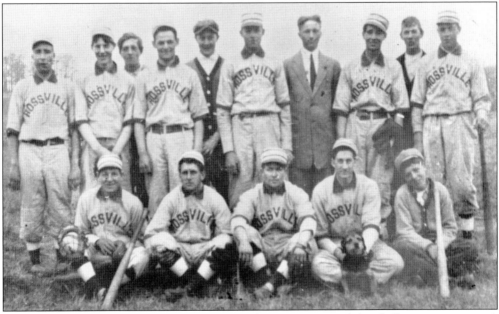

ROSSVILLE BASEBALL. In a team photograph dated May 1912, an early baseball team wears vintage uniforms with the name Rossville. One member is identified on the back of the photograph as "John Howe, future County Executive." This probably refers to John R. Haut, county commissioner from 1938 to 1950. The only other member listed is Fred Herman. (Courtesy Heritage Society of Essex and Middle River.)

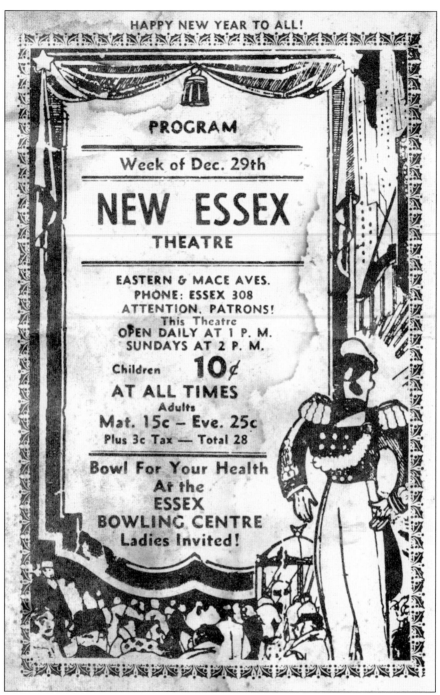

THEATRE PROGRAM. A program from the New Essex and Elektra Theatres, the week of December 29 in an unnamed year, advertises a double feature program promoting Jack Holt in *Fugitive from a Prison Camp* and *Prairie Schooner* starring Bill Elliott. Located in an upstairs theater in the 500 block of Eastern Avenue, the first Essex movie house was built in the 1920s by a Mr. Gutermuth who operated a grocery store downstairs. Later the building was sold to Abe Cohen, who used the first floor as a store and moved the movies up to the 400 block.

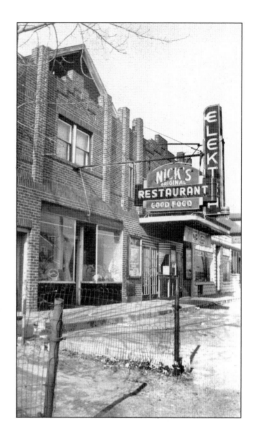

MOVIE HOUSES. Essex had several movie theaters in the early years, among them the Elektra, located at Eastern Avenue and Woodward Drive, and the New Essex Theatre, located near Eastern and Mace Avenues. The deco-style marquee of the Elektra can be seen behind the sign for Nick's Restaurant. The New Essex, in the 1942 photograph shown below, was featuring *One Foot in Heaven* with Frederick March. (Courtesy Heritage Society of Essex and Middle River.)

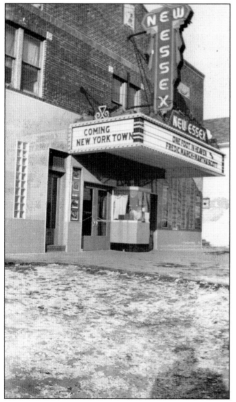

THE LARGEST COCKTAIL LOUNGE IN EAST BALTIMORE
... **BENTZ'S** ...

HOLLYWOOD PARK
—— COCKTAIL LOUNGE ——

Two Shuffleboards TELEVISION — HALL FOR RENT

Dancing Every Wednesday, Friday, Saturday, Sunday Nite

★ **RADIO FAMED STARDUSTERS** ★
★ **HY ANDREWS** ★ **JACK McCRAW** ★

Blind Pianist every Mon., Tues., Wed., Thurs. and
Sunday Cocktail Hour 3-7 p.m.

23 EASTERN AVENUE —★— Essex 1209

HOLLYWOOD PARK. In this 1948 advertisement, Bentz's Hollywood Park at 23 Eastern Avenue touted itself as the "Largest Cocktail Lounge in Essex," with two shuffleboards and a television. The "radio famed Stardusters" performed, along with Hy Andrews, Jack McCraw, and a "Blind Pianist" who entertained patrons five days a week. (Author's collection.)

Dance To ☆ MEL HOWE'S TRIO ☆ Every Friday and Saturday
TELEVISION—SHUFFLEBOARDS—FOOD

COZY INN

BILL ◄— ⫷⫷⫷Your Hosts⫸⫸⫸ —► CAL

REAR OF MIDWAY THEATRE -:- Phone Essex 24-R

MUSIC BY ☆ THE CHORDSMEN ☆ Every Saturday Nite

FOWLER'S BAR — LOUNGE RESTAURANT

Television ☆ Shuffleboards Bud Connelly ◄— ⫷⫷⫷Your Hosts⫸⫸⫸ —► Joe Fitz

900 EASTERN AVENUE : - : **Phone: ESSEX 174**

COZY INN AND FOWLER'S. The two saloons shared an advertisement in a 1948 guide for Baltimore visitors. Cozy Inn was located to the "rear of Midway," the movie theater attached to the Commodore Inn for several years. Fowler's hosts, Bud Connelly and Joe Fitz, welcomed patrons to their bar-lounge-restaurant in the 900 block Eastern Avenue, where the Chordsmen played every Saturday night. (Author's collection.)

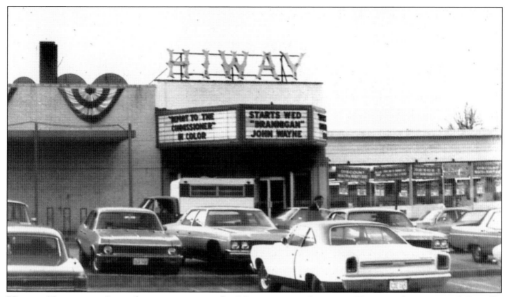

HIWAY THEATER. Saturday matinees at the Hiway movie house at Eastern Avenue and Orville Road featured previews, news, two cartoons, a two-reel comedy, a serial, and a double-feature usually starring cowboy stars Gene Autrey or Roy Rogers. Live stage shows and radio broadcasts also were presented at the Hiway during its heyday in the 1950s. After a movie date, teenagers could enjoy chocolate Cokes at Whelan's Drug Store next door. (Courtesy Robert K. Headley.)

STAGE SHOWS. Tex Daniels and his Lazy H Ranch Boys were among the performers providing live entertainment on the stage of the Hiway movie theater at noon on Saturdays. Shown in this old news clipping, Tex (left) broadcast a radio show, the *Lazy H Ranch Boys Jamboree*, from the location in the late 1940s. Tex also was a DJ on WSID, 1570 K.C., broadcasting from a studio in Essex. (Courtesy *Avenue News*.)

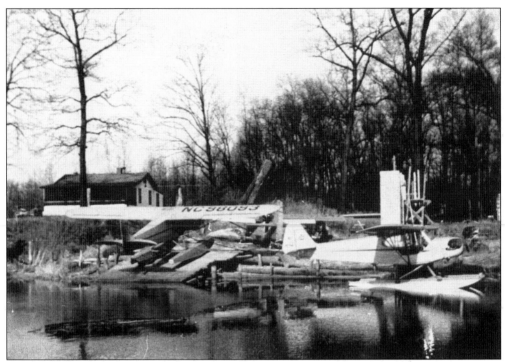

ESSEX SEAPLANE BASE. Harry Carl, founder and owner of Essex Seaplane Base, bought three lots on Back River in 1946 to establish his business. Starting from scratch, he purchased a new 1946 Piper Cub from John Hinson at Harbor Field, also known as the Baltimore Municipal Airport. The seaplane base had one ramp, a pier, and floating docks. The site is now known as Riverside Marine. (Courtesy Eric Carl.)

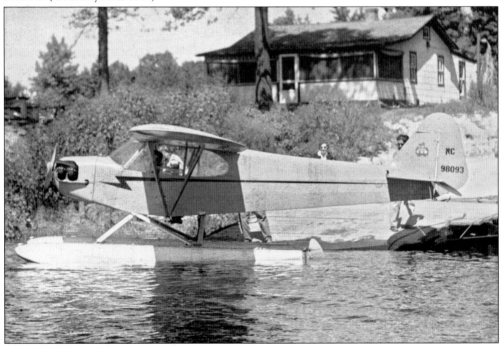

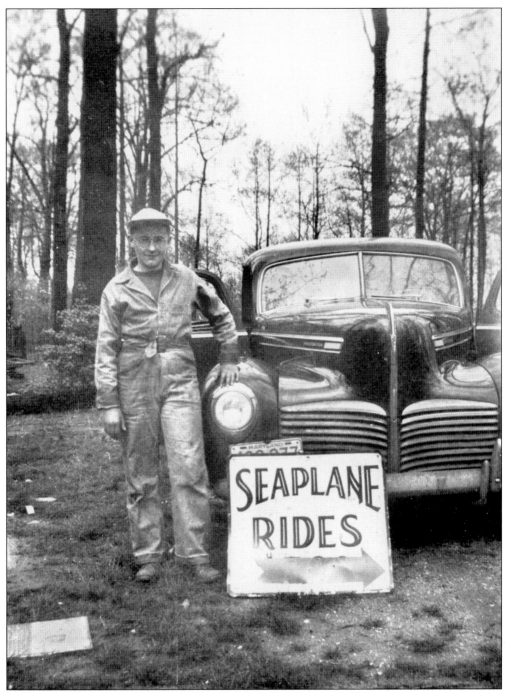

BARNSTORMING. Shown working at the Essex Seaplane Base in 1949, Eric Carl began helping his dad at age 10, and was driving a 1941 Hudson at age 13. Father and son went "barnstorming" with their Piper Cub, visiting farms and fairs, as well as Porters, Bayshore, Tolchester, and Betterton beaches, selling plane rides to the public. The Carls would land on a property with permission from the owner, and Eric would walk through the crowd with a placard hawking $5 seaplane rides while his dad, the pilot, awaited customers. (Courtesy Eric Carl.)

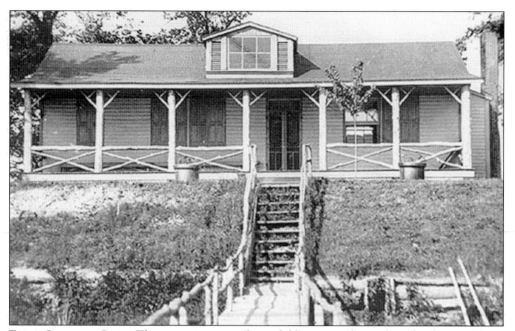

ESSEX COUNTRY CLUB. The attractive, waterfront clubhouse was located on the shores of Deep Creek on Crooks Road, which later became Sandalwood Road, off South Marlyn Avenue. Archie Price ran the bar and nightspot where country and pop music played and peanut shells littered the wooden floors in the 1940s. The club, which had a membership roll but was open to all, was sometimes called Peanut Hall. (Courtesy Baltimore County Public Library.)

TRIPLE HEADER. Mon Zajdel, who ran the Commodore Inn with his wife, Frieda, along with Buck and Rose (Zajdel) Mahle, juggles triple drafts at the bar in the 1950s. Lucky and Helen Zajdel helped out by handling rentals of the Commodore's catering hall. The hall became a movie theater called the Midway, with a lobby, projection, and ticket booth in the 1950s. (Courtesy Roger Zajdel.)

RILEY'S-LYNNWOOD PARK.
In 1955, Charles and Regina Riley purchased the waterfront spot then known as Lynnwood Park. There at the headwaters of Middle River, the family operated a restaurant and boat service that is still in business. Riley's Yacht Inn was housed in a rambling dormered home with large French doors. The family moved into an apartment upstairs. The inn became a popular spot for church and social outings, and while Charles worked outside during the day, Regina helped run the restaurant. The Rileys ran the inn from 1955 to 1969, and when it finally closed, they devoted themselves full-time to marine sales, slip rentals, and repair services. There are a few newer structures on the land now, but the old restaurant building still stands, serving as the office and parts center. (Courtesy Riley family.)

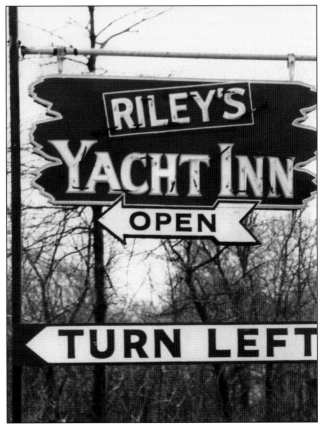

INDEPENDENCE DAY PARADE. A 1924 Chevrolet National Bohemian Beer truck was admired by the crowd as it passed through Essex in an Independence Day parade in the 1970s. The National Brewing Company's Shires also participated in the festivities. The six-horse team is pictured below pulling an old-time beer wagon as a costumed handler in boots and bowler hat walks alongside. (Courtesy Baltimore County Public Library.)

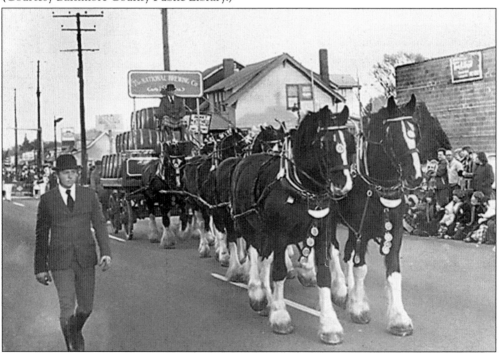

VETERANS DAY. A parade and ceremony in observance of Veterans Day was held in Essex in the early 1950s. In the background is the Watch Shop, offering one-day watch repair; the New Essex Barber Shop; Taubman's auto parts store; and Deckelman's Menswear.

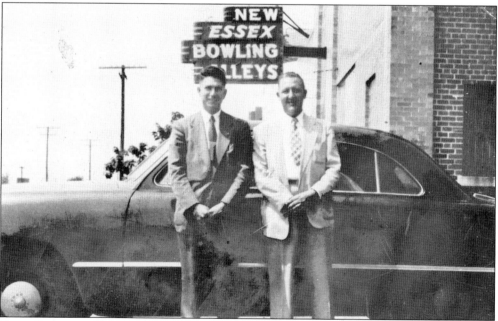

ESSEX BOWLING. Shown in front of the New Essex Bowling Alleys around 1950, Howard Bates (left) and William Weinkam, police officers from the Essex precinct, seem overdressed for the sport. Nevertheless, bowling was a popular activity not only with league play, but for weekend entertainment as well. The wooden bowling pins at the New Essex lanes were set by hand in the early days. (Courtesy JoAnn Weinkam Weiland.)

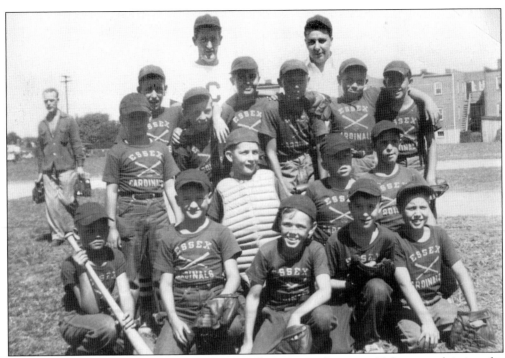

PLAY BALL. Young ballplayers proudly bearing the name and wearing T-shirts proclaiming the "Essex Cardinals" played on the fields of Essex Elementary School in the 1940s. Among their sandlot baseball coaches was Edwin "Reds" Weinkam of Essex. (Courtesy JoAnn Weinkam Weiland.)

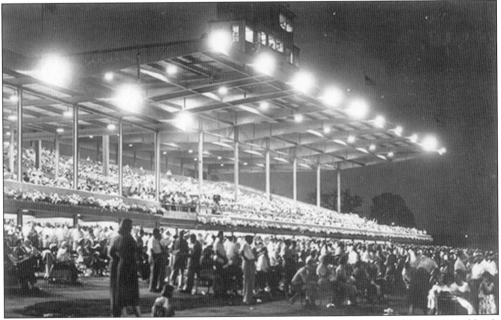

HARNESS RACING. A night view from the stands of the Baltimore Raceway shows a crowd both in the stands and behind the infield fence in this Blakeslee-Lane Studio photograph. The harness racing track drew crowds from Essex, Middle River, and beyond in the early years but lost momentum and closed after 12 years in operation. (Courtesy Baltimore County Public Library.)

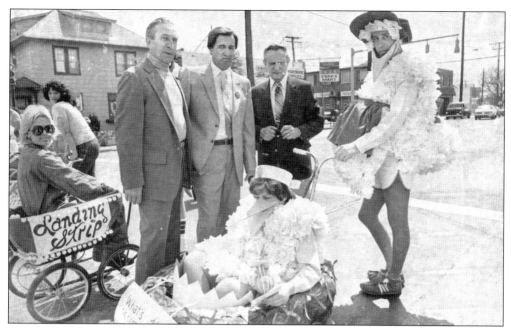

ESSEX DAY. The annual street festival kicked off as a fund-raiser for historic preservation in the mid-1970s and in the early years included a baby buggy race as competition among Essex businesses. Pictured is the *Avenue News* team along with that of the Landing Strip. The festival continues today with headline performers, music, food, vendors, games, and a wide range of activities each year on the third Sunday in September. (Courtesy *Avenue News*.)

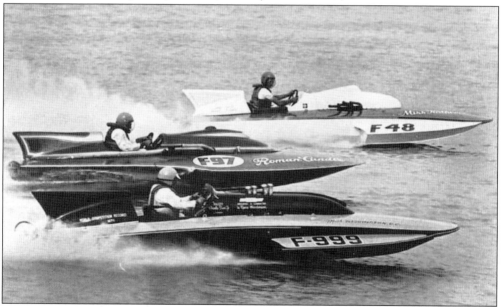

SPEEDBOAT REGATTA. The Governor's Cup Regatta was the most exciting event on Back River off Cox's Point in the 1970s. Dozens of cigarette boats zoomed across the waters of Back River at full throttle while racing for the silver cup. The prestigious event was held at this location on Labor Day weekend for several years. (Courtesy Baltimore County Department of Recreation and Parks.)

THE COASTERS

The Coasters, famous for their hit songs "Charlie Brown", "Yakety-Yak", "Along Came Jones", "Poison Ivy" among others, are as popular in Europe as they are in the United States. They recently completed a tour of Great Britain, and have played the Metropolitan New York area, Las

THE DRIFTERS

"The sound The Drifters introduced has become a favorite. We experimented with it until we found exactly what we wanted. It's hard to explain but when you hear it, it's unmistakeable. We use strings and guitar with rock and roll beat to back it, and carry voices of the quartet on top. But it's a heck of a sound."

THE BROOKLYN BRIDGE

THE BROOKLYN BRIDGE pour out an emotion-packed show that leaves audiences clamoring for more. They are a regular fixture in many top night-spots around the country, and are constantly being asked to return to wherever they play. And, they are currently working on a new album which is certain to return them to the top of

COUNTY FAIR. The Baltimore County Celebrity Fair held from June 16 to 26, 1977, brought headline entertainment and thrills to the Essex–Middle River area as shown in this advertisement. The fair was organized as a nonprofit charitable event in 1976 and continued for just a few years before ending in financial loss. P. David Hutchinson was chairman of the event, which was supported by the administration of County Executive Theodore Venetoulis.

FEATURED ENTERTAINER. Essex resident Stephen Brenner, known as Baltimore's Bozo the Clown, was among the performers drawing young and old alike to the county fair held at Chesapeake Park Plaza. Local performers such as Bozo mingled with headline recording stars on the entertainment stage. (Author's collection.)

The ORIGINAL
BOZO THE CLOWN
Stephen G. Brenner

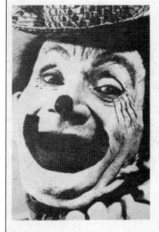

Born and raised in Baltimore County, Maryland. Joined the entertainment world at the age of 11. Formerly with Ringling Brothers and Barnum and Bailey Circus. Now in his eighties and still performing in the finest fashion.

Mr. Brenner has his own "Museum" of photos, handbills, and items from the Big-Top days. Any city that has a TV station may claim to have a "Bozo" — they all seemingly look alike — however, real clowns never dress alike — their makeup is their trademark, their identity.

Mr. Brenner belongs to Clowns of America — the greatest club on earth.

HELL DRIVERS

The craziest, hair-raising nerve-wracking, suicidal auto stunts in history. Side winder head-on flying crashes. A show that will keep all ages on the edge of their seats. Back, once again, will be Jack Kochman's Hell Drivers. The 18 daredevils will perform death defying leaps on motorcycles and many other high speed auto thrill events. See the Hell Drivers every day at the fair. Will they make it on their final attempt at the 4-car broad jump? Find out at the Baltimore County Celebrity Fair.

HELL DRIVERS. There were thrills and spills galore as the Hell Drivers put on a daredevil show at the Baltimore County Celebrity Fair in 1977. Sideshows, magicians, and a demolition derby were among the other attractions.

PETERS' RESTAURANT

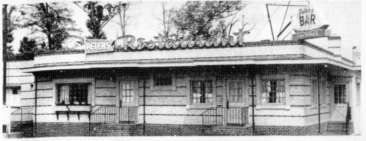

②

SUPERB SERVICE - FOOD & COCKTAILS AT SENSIBLE PRICES

OUR 20th YEAR

1528 EASTERN AVE. ESSEX 21, MD. - MUrdock 6-6600

FINE FOOD. The well-known dining establishments across from Josenhans Corner, Peters' Restaurant and A-1 Crab House, provided many years of enjoyable dining for locals and visitors to the area. Both restaurants were gathering spots for various clubs and group activities and the scene of frequent family celebrations, with seafood specialties as the most popular items on their menus. Peters', owned by Democratic political leader Bill Peters, featured the Essex Room, Terrace Room, and Stemmers Room while the A-1 was decorated with colorful clowns in paintings, sculptures, and figurines, the collection of the owner Mike Pangalis. Peters' location continues as a restaurant site under new ownership while A-1 was demolished and redeveloped as a small supermarket.

Four

BUSINESS, INDUSTRY, AND ECONOMIC DEVELOPMENT

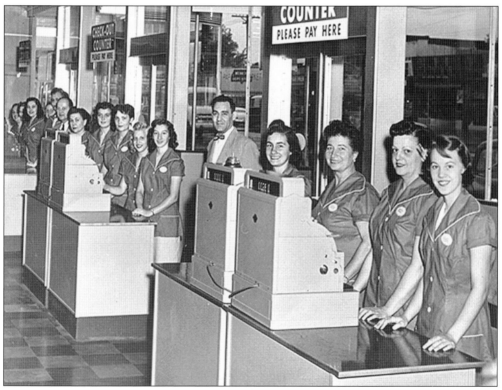

FIVE AND TEN. Cashiers stand ready for duty at the checkout stations of Ben Franklin's variety store in the 500 block of Eastern Avenue in Essex. The store, along with the entire block of businesses, was destroyed by fire about six months after the photograph was taken in August 1957. (Courtesy Baltimore County Public Library.)

SMOKE SHOP. William R. Barber is shown with his granddaughter, Edith Wick, in 1923 outside his cigar shop and newsstand at Eastern Avenue and Riverside Drive. Edith later wed William R. Hurley Sr., according to Heritage Society of Essex and Middle River records. Barber died in 1948 at the age of 92. (Courtesy Heritage Society of Essex and Middle River.)

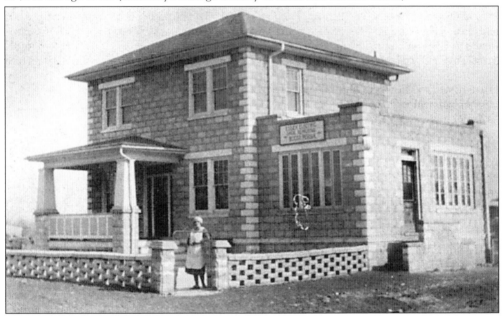

SHOEMAKER'S SHOP. The first shoe repair business in Essex was opened at 13 Margaret Avenue by shoemaker Rocco Persia in 1920. In 1928, a shop was added onto the side of a new residence built by Persia at the corner of Eastern and Margaret Avenues. The building remains in business use today. (Courtesy Heritage Society of Essex and Middle River.)

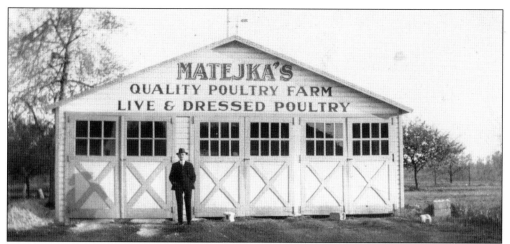

MATEJKA QUALITY POULTRY. Jaroslav Matejka is pictured in 1928 at his wholesale poultry business behind the family's home on Eastern Avenue Road about two blocks from Josenhans Corner. Matejka, a custom tailor turned entrepreneur, purchased chickens and other poultry from local farmers, selling them at a stall in one of Baltimore City's east-side markets. The Matejka Quality Poultry Farm became a full-time business for the family in 1924. (Courtesy Lynn Gittings.)

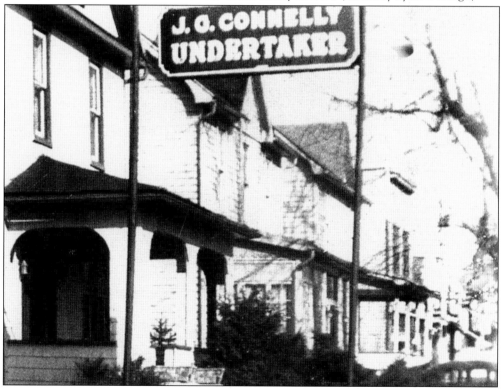

CONNELLY FUNERAL HOME. Shown in a clipping from an Essex 90th anniversary publication, John G. Connelly Undertakers started out in a frame building at 418 Eastern Avenue in the heart of Essex. Connelly Funeral Home expanded with the business's relocation to a large, modern building at 300 Mace Avenue in the early 1960s. (Courtesy Essex Revitalization and Community Corporation.)

AMERICAN DEPARTMENT STORE. From 1921 until about 1950, Mr. and Mrs. Joseph Banz owned and operated the American Department Store at 602 Eastern Avenue. The couple sold dry goods, clothing, and shoes, seen stacked on shelves surrounding Mr. Banz in the photograph. They added a barber shop to the side of the building in 1930. The building later became the office of Philip Green Insurance Company. (Courtesy Margaret Swiss.)

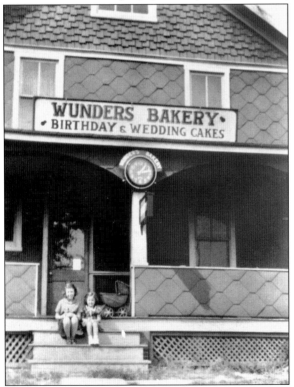

WUNDER'S BAKERY. Frederick Wunder and his family operated a bakery at 506 Eastern Avenue for 35 years. He and his wife, Caroline, lived behind the shop and upstairs, raising their family while running the business. The bakery was well known for its decorated birthday cakes, butter cakes, and smearkase, a dense German cheesecake. Shown on the front porch in 1941 are Dorothy Wunder (Schreiber), left, and Linda Moessinger. (Courtesy Wunder family.)

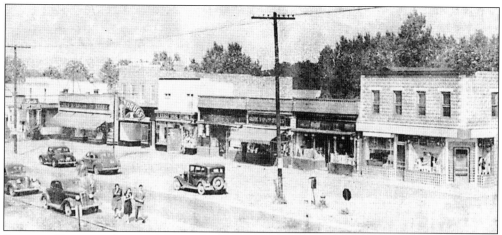

BUSINESS DISTRICT. A view of the north side of Eastern Avenue in Essex shows thriving businesses and heavy traffic in the 1940s. Stores whose signs may be identified are Lee's Department Store, Lee's 5 and 10, Essex Drug, People's, and Globe 5 & 10. (Courtesy *Avenue News*.)

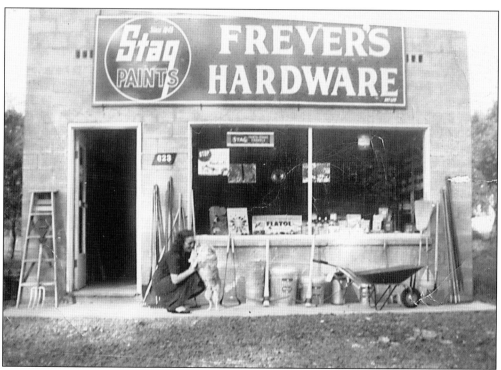

FREYER'S HARDWARE. William Kelso Freyer and his wife, Mary, pictured with the family dog, sold their car to buy property for their business on South Marlyn Avenue in the mid-1940s. They started out selling eggs, animal feed, and nails and took orders for hardware, using the money from daily sales to pay for the orders. (Courtesy Freyer family.)

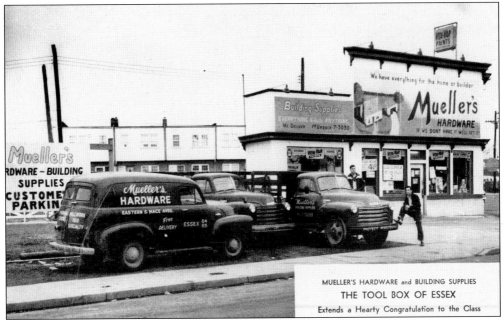

MUELLER'S HARDWARE. Located at the corner of Eastern and Mace Avenues, Mueller's Hardware and Building Supplies was known as "The Tool Box of Essex." Signs in the building's windows show that the store sold peat moss and shotgun shells as well as Vita-Var paint. "If we don't have it, we'll get it," promised Mueller's. The photograph is from an advertisement in the 1954 Kenwood High School yearbook. (Courtesy Patricia Bloom Novotny.)

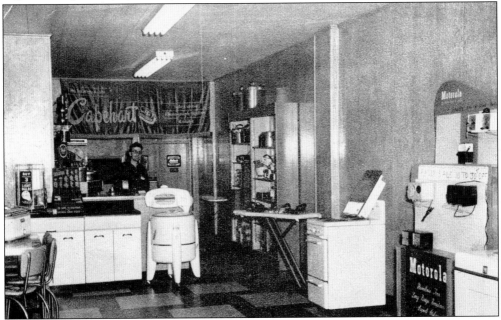

TELEVISION COMPANY OF ESSEX. Located at 405 Mace Avenue, the Television Company of Essex sold Motorola and Capehart televisions and other name brands, along with stoves, washing machines, and radios. The photograph is from an advertisement in the 1954 Kenwood yearbook. (Courtesy Patricia Bloom Novotny.)

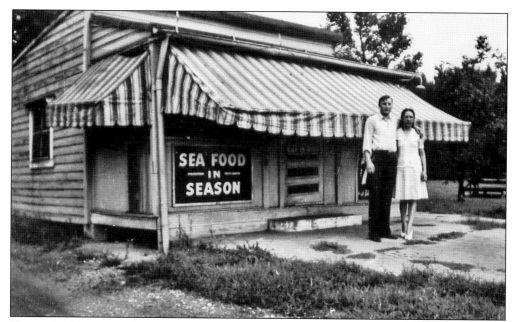

VOGLER'S TAVERN. Buck Vogler had a popular watering hole called Long Lawn View Inn on Back River Neck Road in the 1940s. Over the years, the establishment changed hands and names many times. Among the businesses at the location were bar-restaurants called Ferdinand's, Howie Moss's, Pappy's Beef and Beer, the Kourtyard, and now Jad's Caddyshack. (Courtesy Marge Ziemann.)

ESSEX BANK. The Essex branch of the Overlea Bank is shown on the right in this 1927 news clipping. The scene is of the northern sidewalk of Eastern Avenue looking west from a department store at the corner of Taylor Avenue. (Courtesy Baltimore County Public Library.)

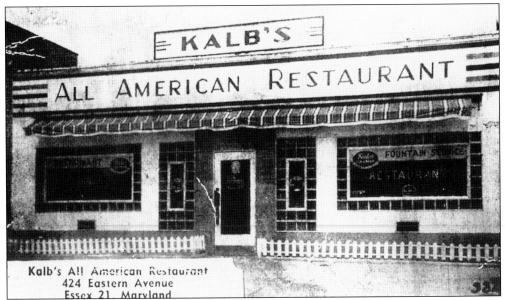

Kalb's All American Restaurant
424 Eastern Avenue
Essex 21, Maryland

KALB'S RESTAURANT. Now known as Uncle Eddie's, Kalb's All American Restaurant at 424 Eastern Avenue in the heart of Essex is shown in this 1940s postcard. With "a reputation for the finest foods, appetizingly prepared and served in a setting of air-conditioned comfort and pleasure," the eatery served "delicious luncheons from 50 cents, dinners from 75 cents" and was open seven days a week.

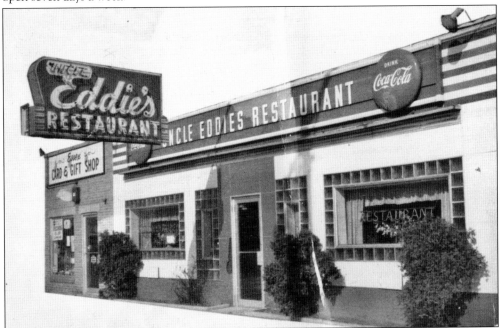

UNCLE EDDIE'S. In 1948, Edward Hockaday purchased Kalb's All American Restaurant and changed the name to Uncle Eddie's Restaurant. He operated the eatery for 30 years, continuing the tradition of reasonably priced, home-cooked meals served in a family atmosphere. John Pierorazio and Ed Geigan continued both the name and tradition when they purchased the restaurant in 1980.

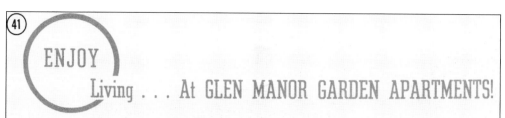
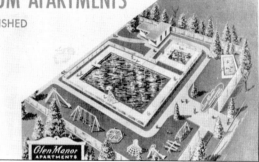
RENTAL HOUSING. Advertisements for apartment complexes in Essex emphasized affordability, a factor that later caused economic problems and deteriorating conditions. Both Mars Estates and Glen Manor helped house the burgeoning workforce of the Glenn L. Martin Company during World War II. Built in 1943–1944, the Mars Estates apartment complex on Old Eastern Avenue consisted of 105 Colonial-style brick buildings, each containing eight apartments. The development, where street names commemorated famous aviators, was named for Glenn L. Martin's flying ship, the *Mars*. Many tenants of both complexes worked at the aircraft factory during and after World War II. The advertisements are from a promotional map of the area. (Courtesy Gary Jennings.)

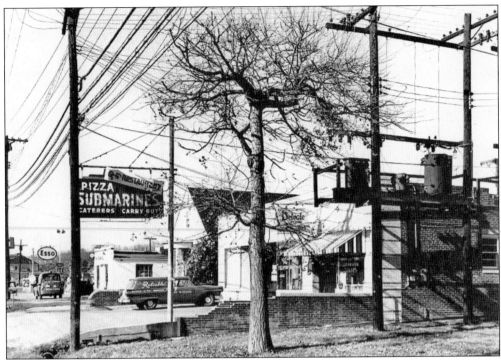

ROMA'S ITALIAN RESTAURANT. With authentic, homemade Italian cuisine on the menu, Roma's was the place to go for veal scaloppini and homemade pasta as well as pizza and subs. There were entrances to the restaurant on both Eastern Boulevard (the dining room) and Old Eastern Avenue (carryout). (Courtesy Baltimore County Public Library.)

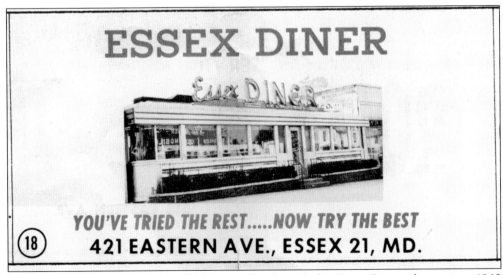

THE ESSEX DINER. Located at 421 Eastern Boulevard, the Essex Diner, shown in a 1960 advertisement, challenged "You've tried the rest, now try the best." The diner, the first of its kind in Essex, was destroyed by fire some years later. (Courtesy Gary Jennings.)

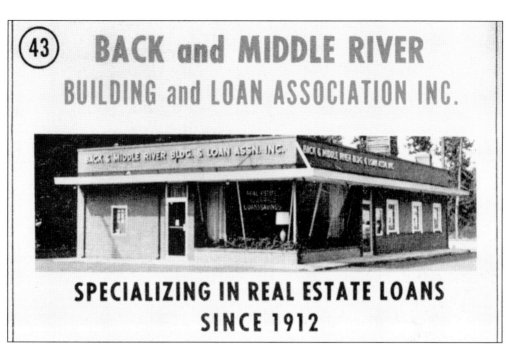

① BACK and MIDDLE RIVER BUILDING and LOAN ASSOCIATION INC.

SPECIALIZING IN REAL ESTATE LOANS SINCE 1912

BUILDING AND LOAN. Back and Middle River Building and Loan Association was founded in 1912 by Daniel Weber, president of the company until his death in 1955. Located on Old Eastern Avenue, the business started out in a room of Weber's Beer Garden. The principal purpose of the association was to finance construction loans and furnish homebuyers with needed funds. Anton Hubers and Daniel Weber Hubers followed Daniel Weber as president.

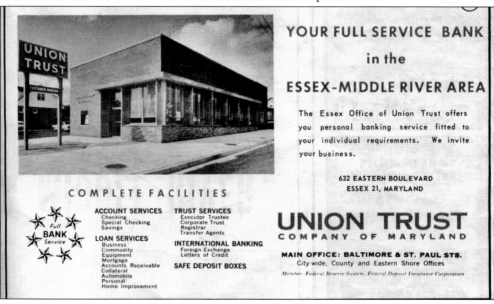

UNION TRUST. The Union Trust Company of Maryland had a branch in Essex at 632 Eastern Boulevard for many years. The full-service bank's main office was at Baltimore and St. Paul Streets. This advertisement is from an early-1960s indexed street map sponsored jointly by the Essex–Middle River Chamber of Commerce and the Optimist Club of Middle River. The corner site has continued as a bank location. (Courtesy Gary Jennings.)

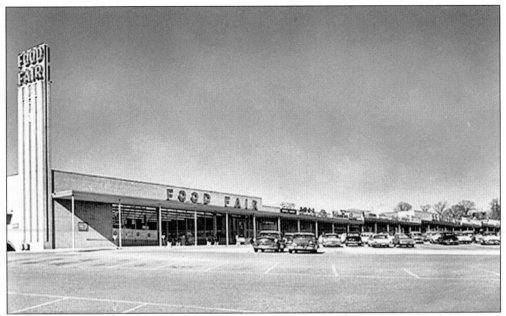

MIDDLESEX SHOPPING CENTER. The Middlesex Shopping Center opened in Essex in the 1950s with a Food Fair supermarket as its anchor. Montgomery Ward department store occupied the opposite end of the strip for many years. Many changes and expansions occurred over the years, the most recent in the late 1990s. (Courtesy Baltimore County Public Library.)

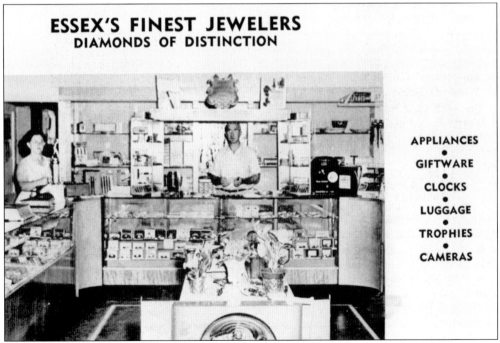

COMMUNITY JEWELERS. Offering a wide array of merchandise and "Terms to Suit You," Community Jewelers purveyed "Diamonds of Distinction" while providing expert watch and clock repairs. Under the ownership of Butch Muenzing, the shop at 403 Eastern Avenue claimed to be Essex's finest jewelers while also selling radios, shavers, appliances, luggage, trophies, and cameras.

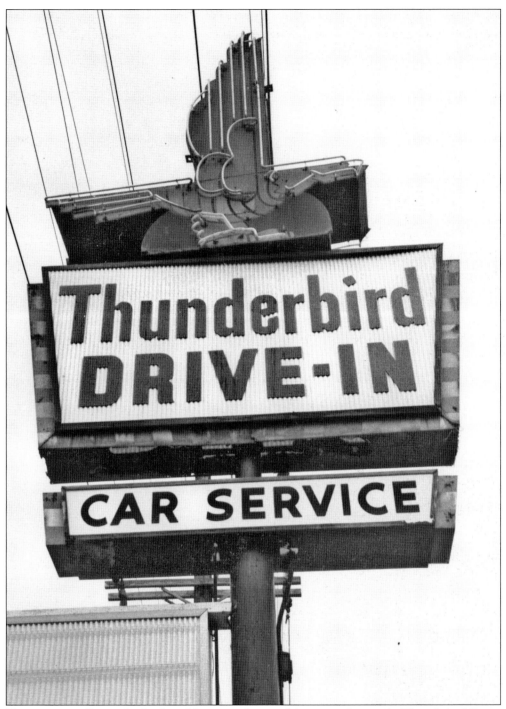

THUNDERBIRD DRIVE-IN. Looking like a set right out of the movie *Grease*, the Thunderbird Drive-In drew throngs of teenagers to Old Eastern Avenue in the 1960s. With the savory Thunderburger topping its menu, the drive-in brought Saturday night customers with flashy cars and souped-up engines to the loud and lively location. The Thunderbird sign was photographed by Vicky Cornell in the 1980s. (Courtesy *Avenue News*.)

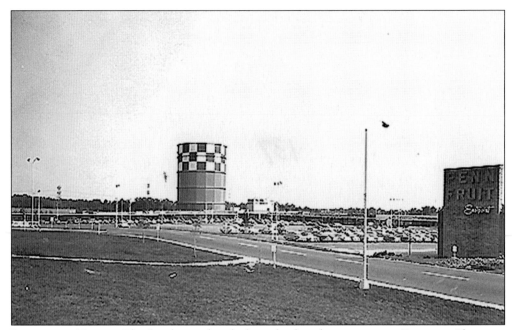

LANDMARK TOWER. The familiar, red-and-white-checkered tower next to Eastpoint Shopping Center was a landmark for Essex residents in the 1950s and 1960s. The shopping center, which included Hutzler Brothers and Hochschild Kohn department stores, became Eastpoint Mall when it was enclosed in the 1970s. The tower, which was a Baltimore Gas and Electric Company gas holding facility, dominated the skyline. (Courtesy Baltimore County Public Library.)

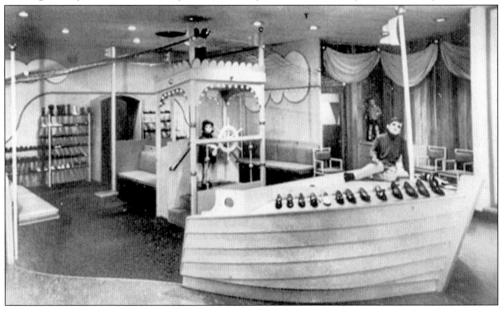

HUTZLER'S EASTPOINT. The children's shoe department of Hutzler's Eastpoint Mall store west of Essex was dominated by a large toy ship with a deck and wheelhouse that children could navigate. In this view, mannequins are seen on the prow and at the wheel. Children sat on the benches behind the wheelhouse and at the sides to try on shoes in 1966. (Courtesy Baltimore County Public Library.)

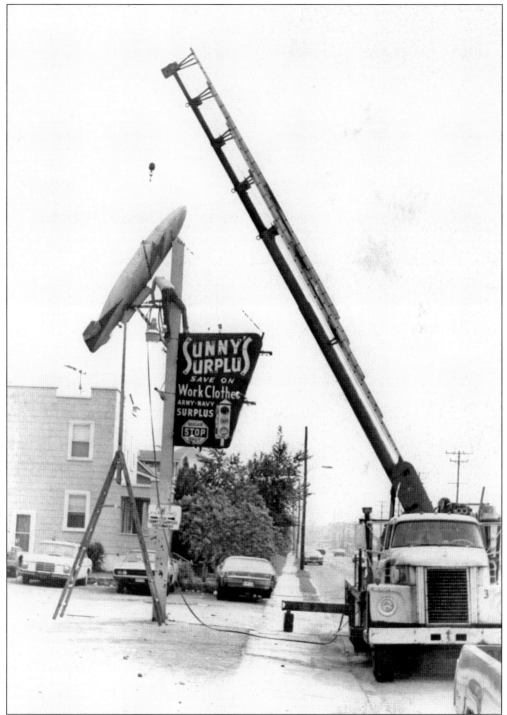

SUNNY'S SURPLUS. The well-known camping and sporting supply store in the heart of Essex also offered a wide array of military surplus items. Sunny's trademark sign, which was removed when the store closed, was accented with a ballistic adornment that drew many young male window shoppers during the GI Joe era. (Courtesy *Avenue News*.)

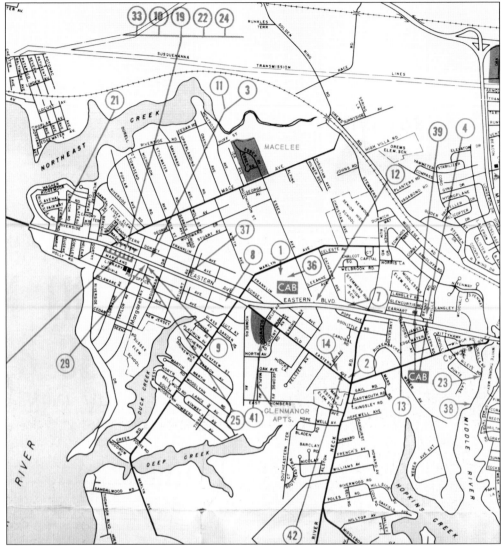

ESSEX MAP. A portion of an indexed street map of Essex–Middle River was produced in 1960 as an advertising vehicle, compliments of Vigilant Building Association at 518 Eastern Avenue. The bank was located in the building originally occupied by the Vigilant Volunteer Fire Company. (Courtesy Gary Jennings.)

Five

STREETSCAPES, VIEWS, AND VISTAS

OFF ROCKY POINT. A member of the Porter family snapped this scene from a pier off the shoreline of Rocky Point Park, a well-known bathing beach and picnic area. First opened in 1924, the park saw its heyday in the 1930s and 1940s. Admission was just 25¢, and children were admitted at no extra charge. Soda pop was available to quench swimmers' thirst, and hot dogs were just 5¢. (Courtesy Ray Porter.)

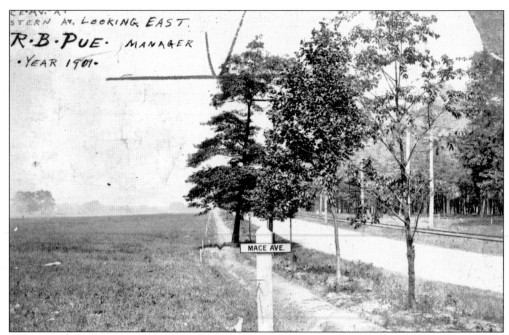

Handwritten on photo:
C.E. AV. AT
STERN AV. LOOKING EAST.
R·B·PUE· MANAGER
·YEAR 1901·

MACE AVE.

MACE AVENUE. A newly planted row of trees adorned the almost-bare intersection of Mace and Eastern Avenues not long after the subdivision of Essex building lots in 1909. Trolley tracks, developers' stakes, and a walking path can be seen along what was little more than a dirt road. (Courtesy Baltimore County Public Library.)

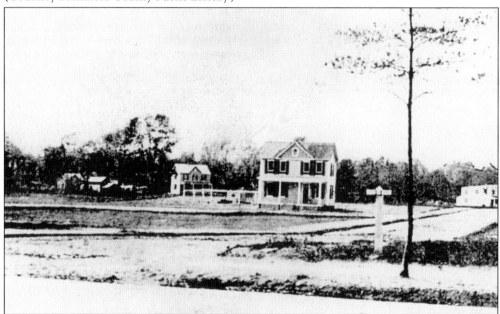

SCHUSTER VIEW. A scene photographed from Eastern Avenue shows a wide angle of Mr. and Mrs. John Schuster's house located at Dorsey and Taylor Avenues. The home, pictured in 1909, is seen surrounded by open fields, with an unobstructed view of the main road and trolley tracks. The dwelling is purported to be the oldest house in Essex. (Courtesy Heritage Society of Essex and Middle River.)

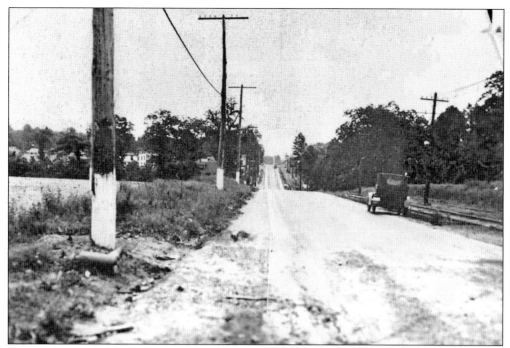

ESSEX ROAD. This 1920s photograph, labeled only "Essex Road," shows a streetcar track at the right with a lone automobile parked along the roadside. New housing and businesses were soon to come to this as-yet-undeveloped strip of land. (Courtesy Baltimore County Public Library—*News American*.)

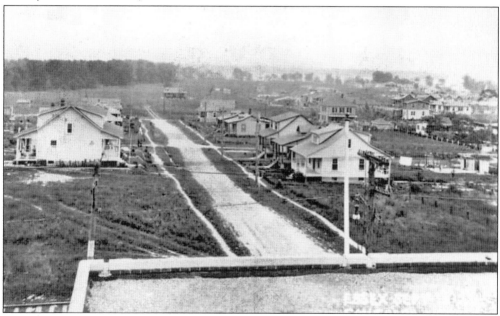

MARGARET AVENUE. The view from the roof of the brand-new Essex Fire Department on Eastern Avenue shows the first new homes to be built on Margaret Avenue. Back River can be seen in the distance in this September 18, 1921, photograph of the sparsely populated town. (Courtesy Baltimore County Public Library.)

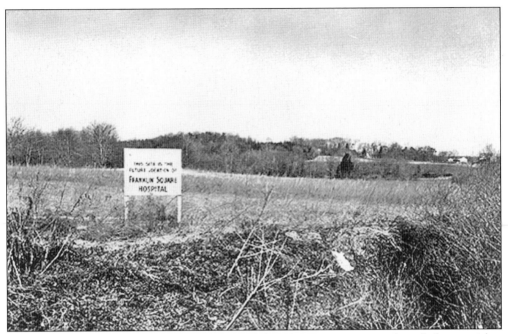

HOSPITAL SITE. The photograph shows part of the Mace tract in an unidentified year with a sign advertising it as the future home of Franklin Square Hospital. Franklin Square moved from Baltimore City to the old Mace family estate on Rossville Boulevard in 1969 and has expanded many times since. (Courtesy Baltimore County Public Library.)

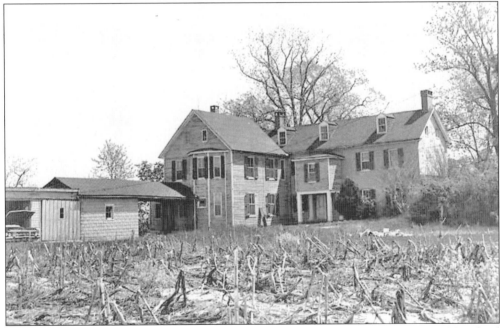

MACE HOME. The backyard of the Rossville-Essex home of Dr. Charles R. Mace faced farmland and rows of corn in the 1920s. Known as the Echoes, the estate was demolished in 1968 to make way for the construction of Franklin Square Hospital and Essex Community College. (Courtesy Baltimore County Public Library—Essex Community College.)

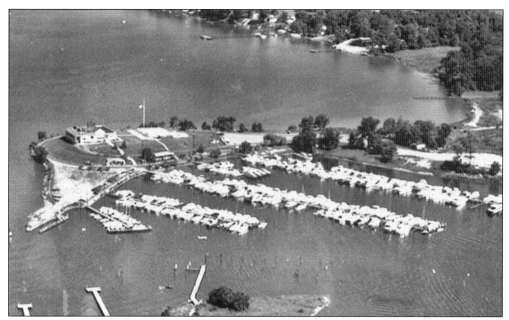

SUE ISLAND. An aerial view of Baltimore Yacht Club (BYC), located on Sue Island at the mouth of Sue (or Sue's) Creek, is shown in this 1950s Blakeslee-Lane Studio photograph. The island was patented to Christopher Duke and documented as "Duke's Discovery" as far back as 1724. Accessible only by boat until 1945, Sue Island, once a haven for bootleggers, has been the home of BYC since 1939. (Courtesy Baltimore County Public Library—George Blakeslee.)

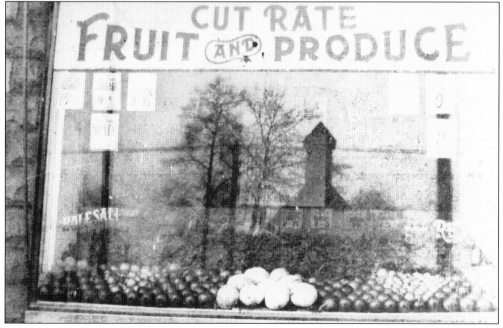

SPIRITUAL REFLECTION. The reflection in a 1920s produce shop window shows Essex United Methodist Church with trees in the background on the opposite side of the road. The store was located on the north side of the 400 block of Eastern Avenue near the corner of Taylor Avenue. (Courtesy Henry Oldewurtel.)

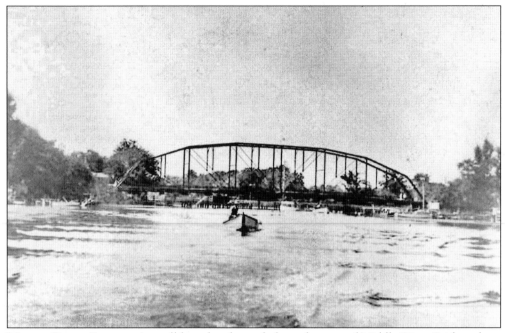

MIDDLE RIVER BRIDGE. A small boat heads south from the area of Middle River Bridge where the water once was wide and deep. Longtime residents of the area recall swimming and boating almost as far north as the railroad tracks in the early 1900s. Baker's rowboat rental business was located on the southeast side of the bridge. (Courtesy Baltimore County Public Library.)

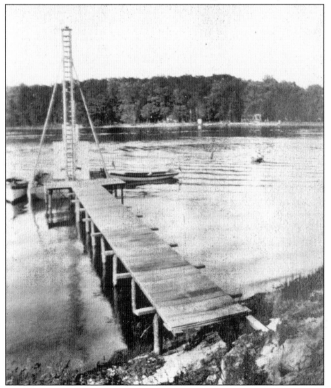

PILE DRIVER. Shown docked in preparation for wharf repair on the Middle River waterfront off Weber Avenue, the pile driver shown was the property of Smooty Mattes. Mattes, a reputed transporter of bootleg whiskey, occupied a house on Sue Island in the 1920s and 1930s. (Courtesy Daniel Weber Hubers.)

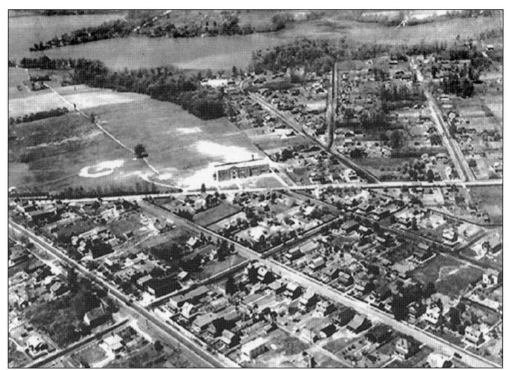

SCHOOL AND SURROUNDING AREA. An aerial view dated 1927 shows the two-year-old Essex Elementary School and its playing fields with adjacent roads, houses, and waterways clearly visible. The road running in front of the school is Mace Avenue. Eastern Avenue can be seen at the lower left corner. (Courtesy Heritage Society of Essex and Middle River.)

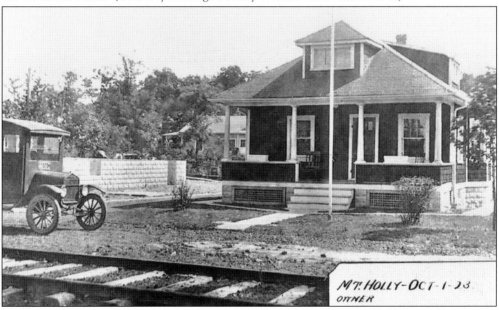

MT. HOLLY-OCT-1-23.
OWNER

MOUNT HOLLY. Streetcar tracks and an unpaved road were in front of a home called Mount Holly in Essex in the early 1920s. The property was owned by Henry Lindner. (Courtesy Heritage Society of Essex and Middle River.)

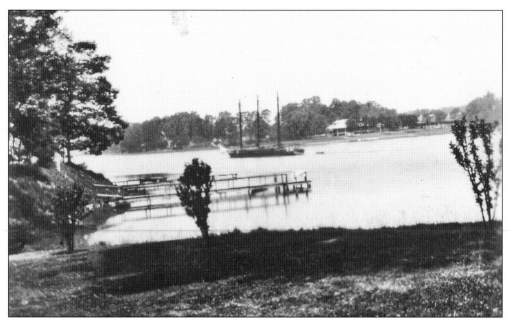

THREE-MASTED SCHOONER. Heading out to Middle River, a large, wooden sailboat might have been the one reported as a "rumrunner" during Prohibition days. Bootleg whiskey was distilled and transported regularly along the rivers of Essex and Middle River in the late 1920s. (Courtesy Daniel Weber Hubers.)

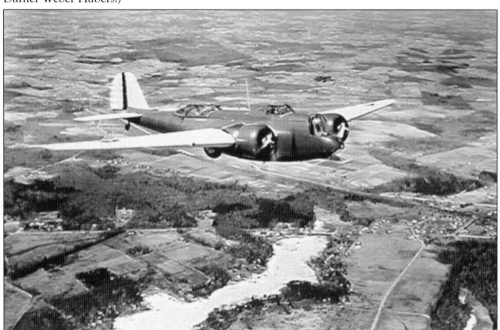

WORLD WAR II AERIAL VIEW. The renowned Glenn L. Martin Company B-26 bomber, known as the *Marauder*, was a familiar sight over Essex and Middle River during World War II. From 1941 to 1945, some 5,288 of the bombers were built, becoming one of the nation's most effective weapons in World War II. Employment opportunities at the Martin Company significantly contributed to the area's growth during the 1940s. (Courtesy Glenn L. Martin Maryland Aviation Museum.)

AERIAL MANEUVERS. Pilot Harry Carl took this photograph while in his Piper Cub seaplane flying over the Essex area in the mid-1940s. Carl worked in the engineering department of the Glenn L. Martin Company and was the owner of the Essex Seaplane Base on Riverside Drive, Back River. (Courtesy Eric Carl.)

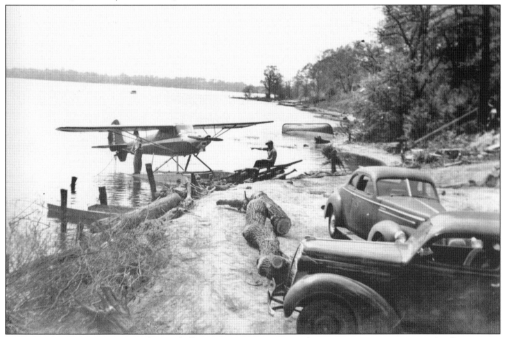

BACK RIVER BEACH. Seaplanes belonging to Essex Seaplane Base owner Harry Carl are seen docked along the Back River shoreline in 1946. Carl's business was located on Riverside Drive, the current location of Riverside Marine. (Courtesy Eric Carl.)

HEADING EAST. The 1700 block of Eastern Avenue in Essex is shown in a photograph dated February 17, 1959. The photograph was taken by Baltimore Gas and Electric Company staff photographer Steve Corfidi. (Courtesy Peale Museum—Baltimore County Public Library.)

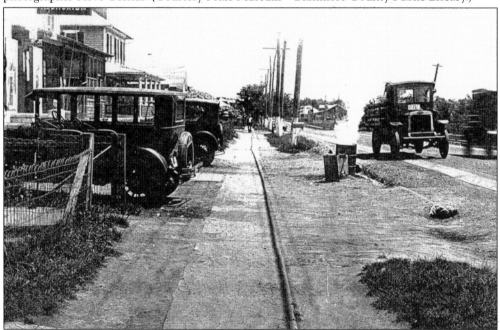

SIDEWALK VIEW. A clipping from an unnamed source dated June 6, 1927, shows Eastern Avenue just west of Woodward Drive, looking east from the Auditorium Meat Market on the left. The roads were rough with deep drainage gutters running alongside while small front yards were taken up by driveways for family cars. (Courtesy Baltimore County Public Library.)

Six

WATER SPORTS ON BACK AND MIDDLE RIVERS

SETTING SAIL. Essex has shoreline along both Back and Middle Rivers. In this 1920s photograph, young friends at an Essex family home prepare to launch a model sailboat on the Middle River waterfront. (Courtesy Daniel Weber Hubers.)

NATIVE AMERICAN CAMP. Like Native American settlers before them, local children at play huddled around tents and teepees along the idyllic riverfront in the 1920s. Note the creative cooking arrangement in front of them. In tales these children are certain to have heard from their grandparents, it was said that Native American grave sites were located in various coastal areas of Essex. (Courtesy Daniel Weber Hubers.)

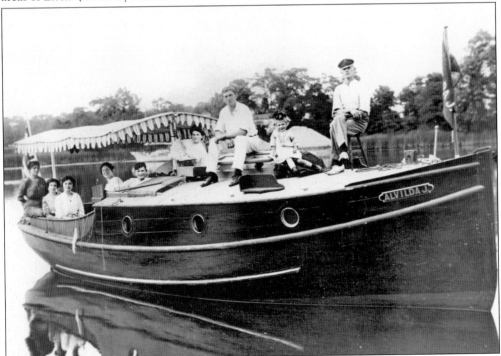

AT ANCHOR. Members and friends of the Popke family enjoy a relaxing day on Middle River in their wooden launch, the *Alvida J*, anchored off Turkey Point at Rockaway Beach in the early 1900s. (Courtesy Baltimore County Public Library.)

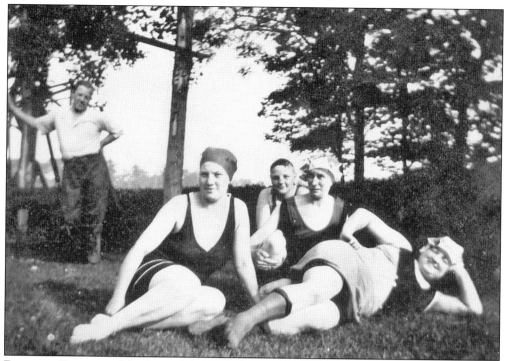

BATHING BEAUTIES. Members of the Nickel family are decked out in the latest swimwear as they pose for a photograph in the 1920s. The location is the Nickels' waterfront property on Rockaway Beach at the mouth of Sue Creek, which has been in the family since 1916. (Courtesy Nickel family.)

TAKING A DIP. Photographer William C. Kenney captured this image of Sidney T. Nimmo and friends on his powerboat on Middle River early in the 1920s. Included are Mrs. Hess, Elizabeth Kenny, Thelma Hess, Elizabeth Watson Gessford, Edmund T. Kenney (with back turned), and Nimmo helping Virginia Merryman Thomas out of the water. (Courtesy Baltimore County Public Library.)

Rowing on the River. Dorothy Kunkle and Dan Hubers took turns manning the oars in a heavy wooden rowboat off Weber Point in the 1920s. The weight of such utility boats served to deter youngsters tempted to stray too far from homeport. (Courtesy Daniel Weber Hubers.)

Bon Voyage. Florence Brown and daughters Katherine (center) and Roberta prepare to launch their rowboat from the shoreline of Back River in this photograph dated 1931. (Courtesy JoAnn Weinkam Weiland.)

DAY AT THE BEACH. William and Katherine Weinkam of Essex lounge against their 1937 roadster, taking a swim break during a Sunday outing at a local bathing beach. (Courtesy JoAnn Weinkam Weiland.)

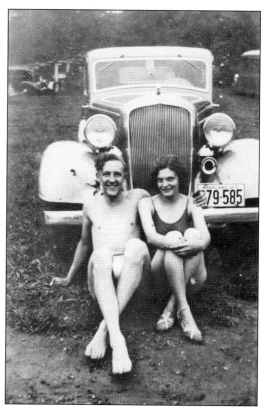

KEENE FLEET. A flotilla of small boats, some with colorful awnings, decorated the waterfront of Back and Middle Rivers in the early days. The Keene family fleet, shown off the shore of their Turkey Point home in the 1930s, provided recreation for young and old alike. (Courtesy Evelyn Reed.)

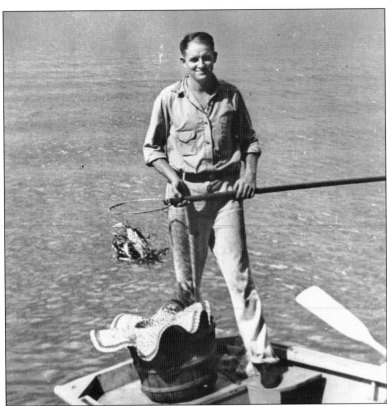

CRAB CATCH. Essex business owner Albert Pospisil is shown catching Maryland blue crabs using hand lines and a dip net off the family's shorefront property in Bowleys Quarters in the 1940s. (Courtesy Mary Pospisil.)

ICE BREAKER. Winters on the waterfront provided unique sights such as this Martin Company utility boat cutting through the frozen river in the 1940s. Frigid waterfront winters provided opportunities for ice skating, ice sailing, joyriding, and bonfires on the ice. There were even attempts at ice fishing. (Courtesy Beverly Brady.)

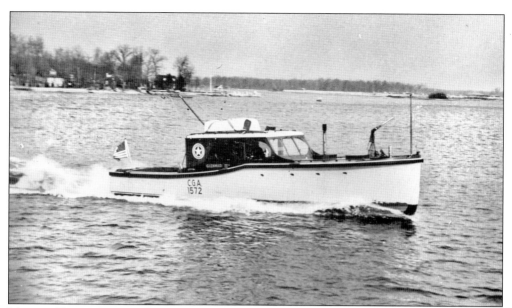

MARTIN FLEET. Capt. William Wilson Moffett was captain of the *Glenmar II*, shown, and also cocaptained, under Capt. William Devereaux, Glenn L. Martin's personal yacht, the *Glenmar*. Martin had several boats in his Middle River collection. His well-appointed pleasure craft carried famous and important passengers on sightseeing jaunts around the Chesapeake Bay, while smaller vessels did patrol duty and served more utilitarian purposes. (Courtesy Beverly Brady.)

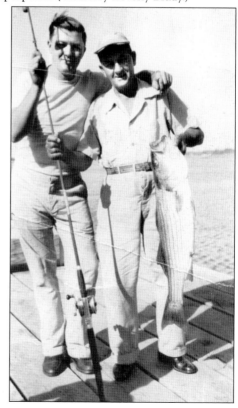

FISH STORY. Buddy and John H. ("Hon") Nickel brought home many large rockfish after a day on the bay aboard their fishing and pleasure boat, the *Miss Gayety*. The yacht, named for the burlesque house owned by the Nickels for over 50 years, was docked at the family home located in Rockaway Beach on Middle River at the mouth of Sue Creek. (Courtesy Nickel family.)

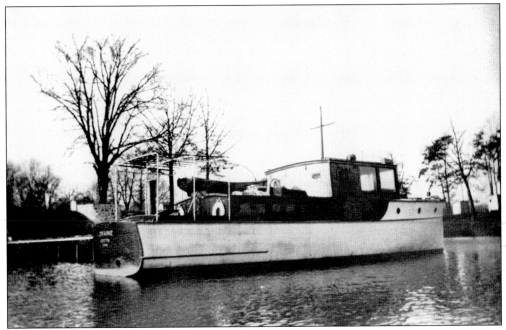

WEBER YACHT. The Weber family enjoyed fishing, swimming, and other water activities aboard their pleasure cruiser docked in Middle River. They were among the earliest members of the Baltimore Yacht Club at Sue Island. (Courtesy Daniel Weber Hubers.)

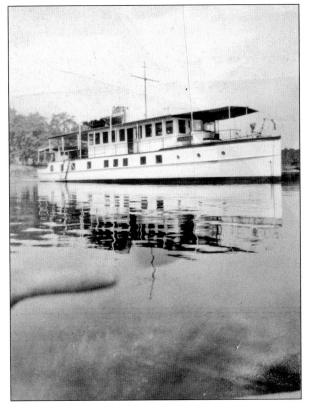

MIAMI BOUND. An 82-foot charter yacht owned by family members visited the Weber-Hubers' Middle River home on its way from New York to Miami. Berthed at its winter homeport in Miami, the yacht was chartered by famous personalities such as Fred Astaire. (Courtesy Daniel Weber Hubers.)

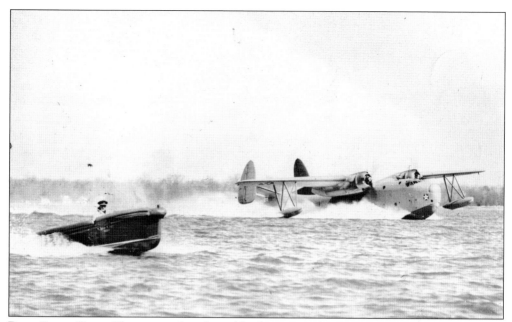

BOAT-PLANE RACE. The testing of seaplanes like the *Mars* airship at the Glenn L. Martin Company in the 1950s provided a unique opportunity for speedboaters racing alongside. Although patrol boats from the aircraft company generally kept boaters away from the planes, many navigators and water-skiers enjoyed catching a wave from the seaplane's wake. (Courtesy Beverly Brady.)

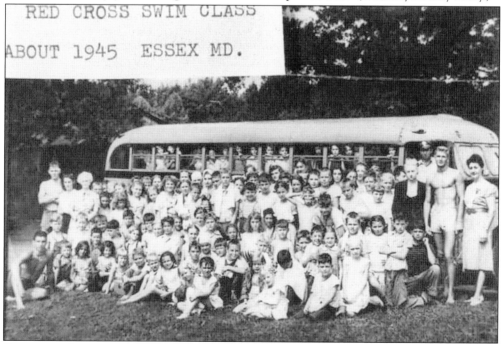

SWIMMING LESSONS. A Learn to Swim class was sponsored by the American Red Cross at Weber's Beach in July and August 1947. Bus transportation was funded by the Essex–Middle River Chamber of Commerce; the Baltimore County Sportsmen's Club, Inc.; and a Mr. Tasch of Mars Estates. (Courtesy Baltimore County Public Library.)

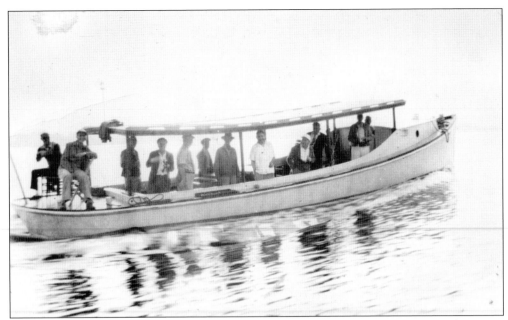

PARTY BOAT. A large, open fishing boat carrying friends and family headed out from the waters of Back River to popular fishing grounds on the Chesapeake Bay is pictured. Rockfish from the clear and bountiful waters were brought home and enjoyed for dinner that same day. (Courtesy JoAnn Weinkam Weiland.)

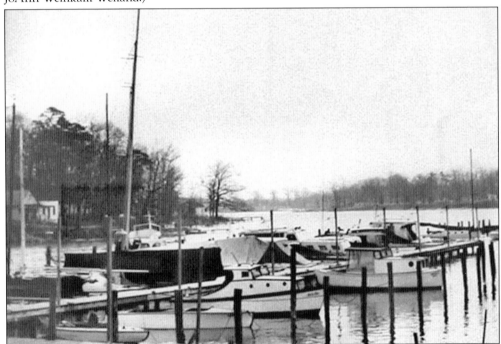

YACHT CLUBS AND MARINAS. Riley's Yacht Inn off Old Eastern Avenue on Middle River also offered marina services and slip rentals for sailboats and other watercraft in the 1950s. While the area was known for its workboats and pleasure craft, Middle River also became popular with sailors and speedboat enthusiasts in the 1940s and 1950s. (Courtesy Riley family.)

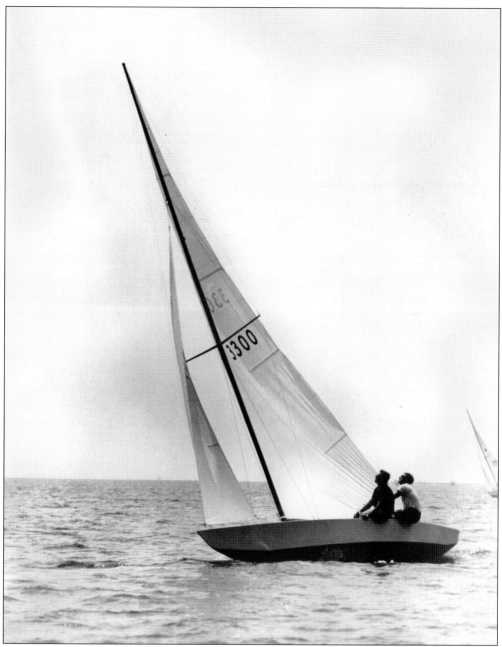

NORTH CHESAPEAKE BAY STAR FLEET. Baltimore Yacht Club at Sue Island was the home of the North Chesapeake Bay Star Fleet, which successfully engaged in worldwide competition in the 1950s. Dan Hubers was the skipper of several championship Star boats that earned him, among other awards, second place representing BYC and Baltimore County in Portugal in 1952. He also traveled to Naples, Italy; to Rio de Janeiro, Brazil, where his boat finished second; and to the New Orleans 1956 Silver Star Event, where he placed 5th out of 49 entries. A Star is 22 feet, 7 inches long and weighs 1,300 pounds with a sail area of 275 square feet. Hubers chose the Star because it was fast, stable, and competitive. There were six Star fleets on the bay in the 1950s, and BYC's was the largest. (Courtesy Daniel Weber Hubers.)

DANIEL WEBER HUBERS. The son of Anton and Anna Weber Hubers, Daniel Weber Hubers, shown in early-1940s swimming attire, has spent his life on and around the Chesapeake Bay. An avid and expert sailor, he took his Star boat to championships all over the world representing Baltimore Yacht Club and Baltimore County. (Courtesy Daniel Weber Hubers.)

ANTON AND ANNA WEBER HUBERS. Mr. and Mrs. Anton Hubers, Tony and Anna as they were known, were a dashing couple on the Middle River waterfront in the 1940s. Sporting nautical attire and a Chesapeake Bay trademark National Bohemian beer as an accessory, they made a visual statement endorsing Natty Boh's motto, "From the Land of Pleasant Living." (Courtesy Daniel Weber Hubers.)

Seven

ESSEX LEADERS IN GOVERNMENT AND POLITICS

THREE COUNTY EXECUTIVES. Baltimore County executive Theodore Venetoulis, who served from 1974 to 1978, is shown gesturing at a press conference in Essex flanked by two future county executives. Donald Hutchinson, left, served as county executive from 1978 to 1986, and Dennis Rasmussen, right, occupied the executive office from 1986 to 1990. Both were from Essex. (Courtesy *Avenue News.*)

MICHAEL J. BIRMINGHAM. In 1958, an East Side–area political figure, Michael J. Birmingham, became Baltimore County's first county executive under charter government. This portrait was done in 1952 when Birmingham was a county commissioner. (Courtesy Baltimore County Public Library.)

CHRISTIAN M. KAHL. The first county executive elected for a full, four-year term (1958–1962), Baltimore County executive Christian Kahl had close ties to the Essex area. (Courtesy Heritage Society of Essex and Middle River.)

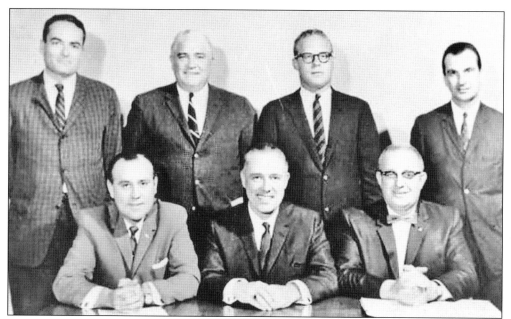

BALTIMORE COUNTY COUNCIL, 1962. The Baltimore County Council of 1962–1966 was comprised of, from left to right, (seated) one-time Essex–Holly Neck resident and future county executive Dale Anderson, D–fifth district; Chairman Frederick L. Dewberry Jr., D–first district; and Essex–Hyde Park resident Joseph L. Schield, D–sixth district; (standing) Samuel Green, D–fourth district; Wallace A. Williams, D–seventh district; Jervis S. Finney, R–second district; and G. Walter Tyrie Jr., D–third district. (Courtesy Baltimore County Council.)

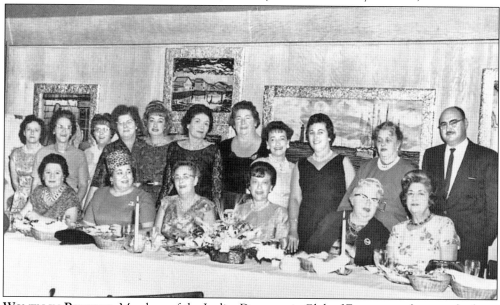

WOMEN IN POLITICS. Members of the Ladies Democratic Club of Essex were photographed at a dinner following the installation of officers in the 1960s. Shown from left to right are (first row) Evelyn Krs, Evelyn Oakes, Jen Mohr, Elsie Steka, Gertrude Carter, and Kay Wolfe; (second row) Clara Davis, Catherine Kronnewetter, Elaine Albrecht, Emma Mock, Delores Collins, Gertrude Cowan, Jean Buskirk, Mary Ford, Thelma Jednoralski, Violet Brooks, and Bill Peters.

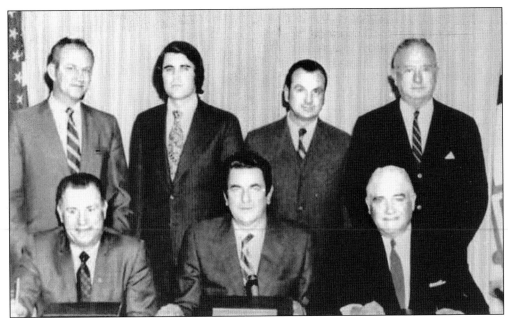

BALTIMORE COUNTY COUNCIL, 1970. The Baltimore County Council members serving from 1970 to 1974 were, from left to right, (seated) Essex-Middleborough resident Harry J. Bartenfelder, D–fifth district; Chairman Francis C. Barrett, sixth district; and Wallace A. Williams, D–seventh district; (standing) Webster C. Dove, fourth district; Gary Huddles, D–second district; G. Walter Tyrie Jr., D–third district; and Francis X. Bossle, first district. (Courtesy Baltimore County Council.)

JAMES A. PINE. Representative of the Eastern area of the Baltimore County in the Maryland General Assembly, State Senator James A. Pine addressed an unidentified group during his last campaign in 1974. George Hensler is on his left; the woman on the right is unidentified. (Courtesy Baltimore County Public Library.)

PARTY LEADERS, 1974. A group of Essex-area Democratic Party candidates and activists with a platform focused on political reform posed for this group photograph in 1974. Pictured from left to right are Michael H. Weir, Dennis F. Rasmussen, Donald P. Hutchinson, Norman W. Lauenstein, Terry Connelly, Quentin Eckenrode, Mae Tutchton Matarozza, and James Hart. (Courtesy Heritage Society of Essex and Middle River.)

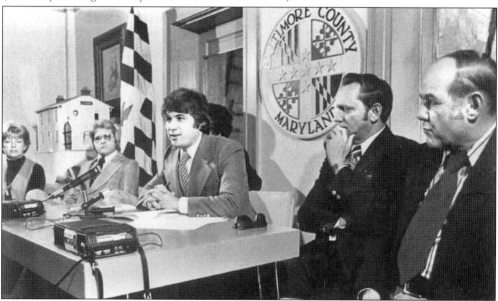

REVITALIZATION PLAN. In a 1976 photograph, County Executive Theodore Venetoulis (center) announces the selection of Murphy-Williams, a Philadelphia consulting firm, to conduct preparatory studies for the revitalization of the Essex business district. With him are, from left to right, Mae Matarozza, member of the State Democratic Central Committee; Delegate Dennis Rasmussen; Sixth District Councilman Norman Lauenstein; and Delegate Peter Basilone. (Courtesy Baltimore County Office of Communications.)

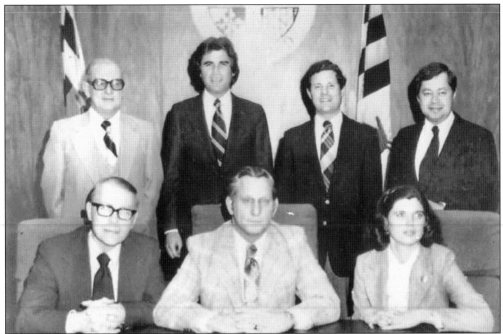

BALTIMORE COUNTY COUNCIL, 1978. Baltimore County Council members serving from 1978 to 1982 were, from left to right, (seated) Eugene W. Gallagher, D–sixth district); Essex representative and Chairman Norman Lauenstein, (D–fifth); and Barbara F. Bachur, (D–fourth); (standing) John W. O'Rourke, (D–seventh); Gary Huddles, (D–second); future–county executive James T. Smith Jr., (D–third); and Ronald B. Hickernell, (D–first). (Courtesy Baltimore County Council.)

Area Politics

The 15th District Democratic Club spawned many future political leaders including Mike Birmingham and Jim Pine.

Bill Daley's 15th District Democratic Club feted the leader of the Democratic Party in Baltimore County, Michael J. Birmingham, Sr., at a special testimonial dinner held at Decker's Grove in the 1960s.

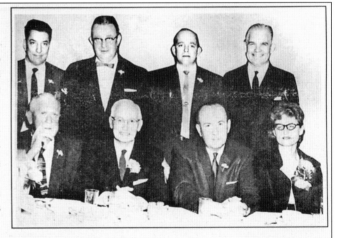

State Senator James A. Pine and A. Gordon Boone joined in eulogizing "Mister Mike" for his astute and understanding leadership in his years of public service. More than 300 of the leading citizens and county dignitaries were on hand for the testimonial event. Shown at the head table during the ceremonies are Louis Ambrosetti, William Daley, Joseph Schield, Mr. Birmingham, John Smith, Senator and Mrs. Pine, Clarence Long.

PARTY POLITICS. An article from Essex's 90th anniversary booklet *Ninety Years of Yesterdays* described the powerful 15th District Democratic Club of mid-20th-century Essex. (Courtesy Essex Revitalization and Community Corporation.)

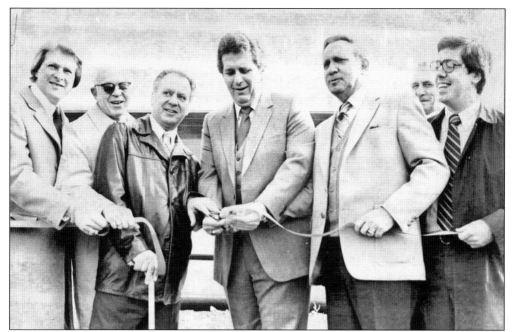

RIBBON CUTTING. Shown at an unidentified ribbon-cutting event in Essex in the early to mid-1980s are State Senator Dennis Rasmussen, left; County Executive Donald Hutchinson, center; Councilman Norman Lauenstein; Del. Michael Weir; and Del. Michael J. Collins, right. (Courtesy *Avenue News.*)

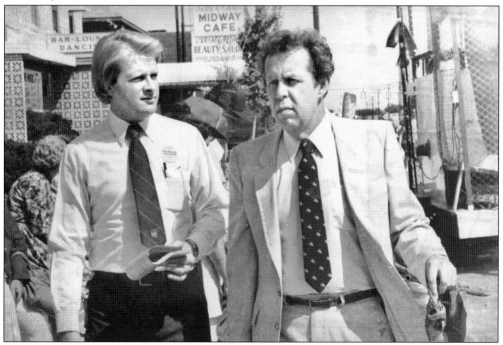

TALKING TOUR. County Executive Dennis Rasmussen, left, appears to be deep in conversation with aide David Hutchinson as they walk in the 500 block of Eastern Boulevard in the late 1980s. (Courtesy *Avenue News.*)

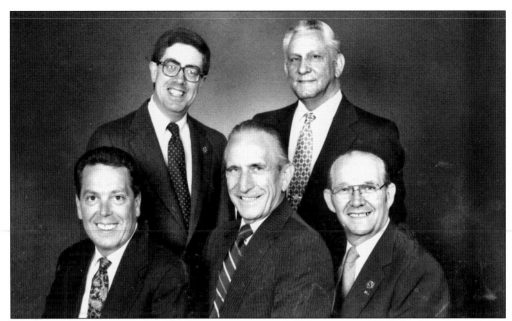

DEMOCRATIC TEAM. Shown in their official campaign photograph in 1990 are, from left to right, (first row) Terry Connelly, Michael Weir, and Farrell Maddox, local members of the Maryland House of Delegates; (standing) State Senator Michael J. Collins and Baltimore County councilman Norman Lauenstein. (Courtesy *Avenue News*.)

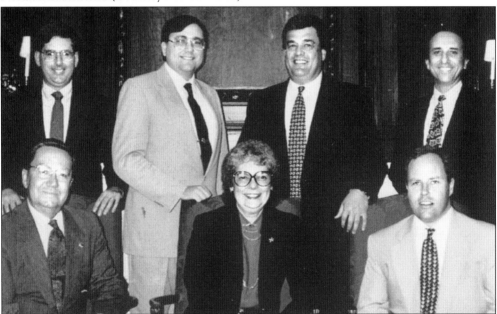

BALTIMORE COUNTY COUNCIL, 1990. Members of the Baltimore County Council, serving from 1990 to 1994, are shown from left to right: (first row) Donald C. Mason, D–seventh district; Berchie Lee Manley, R–first, chairman; and Vincent J. Gardina, D–fifth, representing Essex; (second row) Douglas B. Riley, R–fourth; William A. Howard IV, R–sixth; future county executive C. A. "Dutch" Ruppersberger, D–third; and Melvin G. Mintz, D–second. (Courtesy Baltimore County Council.)

Eight

SURVIVAL, REVIVAL, AND PLANS FOR THE FUTURE

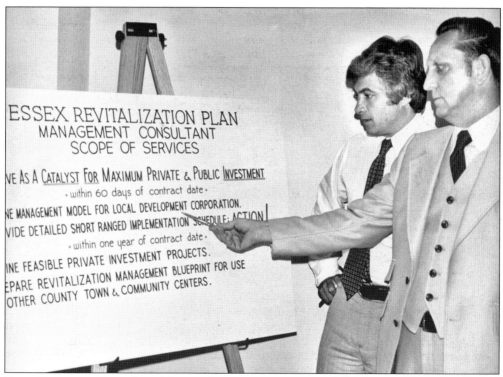

ESSEX RENEWAL. Councilman Norman Lauenstein points out details of a new Essex Revitalization Plan to County Executive Ted Venetoulis in the mid-1970s. Many attempts at the redevelopment of Essex were initiated throughout the years, but little progress was made until the efforts, beginning in 2000, of the administrations of County Executives C. A. Dutch Ruppersberger and James Smith. (Courtesy *Avenue News*.)

DESTINATION ESSEX. In the late 1800s, a streetcar line opened the way to waterfront delights such as Hollywood Park on Back River. Summer car 2665, depicted in pen and ink by George Hensler, was built in 1894 by the Brownell Car Company. There was no center aisle, passengers boarded and disembarked from running boards on the side, and conductors "walked the plank" to collect fares. (Courtesy Heritage Society of Essex and Middle River.)

STORM OF THE CENTURY. The Back River streetcar bridge was destroyed by the devastating tropical storm of August 1933, when boats actually washed up onto the tracks and destroyed the crossing. The bridge continued to be used for vehicular traffic, but transit buses soon took the place of streetcars. A new, concrete bridge was completed in the early 1940s and the crossing was rebuilt again in the 1980s.

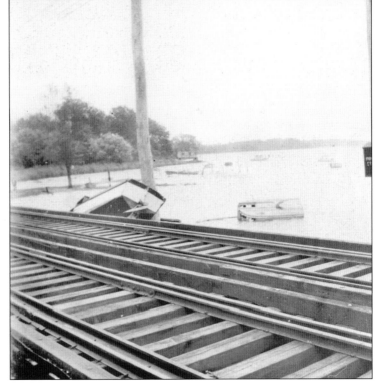

THRIVING ESSEX. The Essex business district was bustling in the 1940s and 1950s with a vibrant economy and plenty of customers lured to the area by wartime industrial jobs. The Glenn L. Martin Company, Sparrows Point, and Eastern Stainless Steel brought not only employment opportunities, but a healthy consumer base to Essex. Shops and stores like Read's Drug Store, with the catchphrase "Run Right to Read's"; Ben Franklin variety store, known as a 5 and 10; New Essex and Elektra movie houses, where cowboys ruled the silver screen; Nick's Restaurant, whose motto was simply "Good Food"; along with numerous clothing and furniture stores energized the heart of Essex. The vibrant 500 block of Eastern Avenue soon would be reduced to ash and cinders. (Courtesy Heritage Society of Essex and Middle River.)

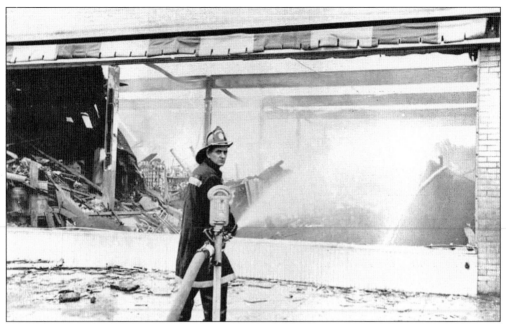

ESSEX FIRE, 1957. A 10-alarm fire on August 3 and 4, 1957, wiped out seven businesses and a bank on Eastern Avenue in Essex—the entire 500 block. Included were the Acme and A&P supermarkets, Read's Drug Store, the Ben Franklin variety store, a C&P Telephone Company office, a furniture and bedding storage warehouse, and Arnold's Men's and Women's Shop. The flames were reported to be 100 feet high, and the estimated damage to the eight gutted businesses was over $1 million. An investigation showed that the fire had originated in a basement furniture warehouse in the middle of the block. These photographs show an unidentified firefighter with a hose working on the ruins of the Ben Franklin store and a view of the aftermath. (Courtesy Baltimore County Public Library.)

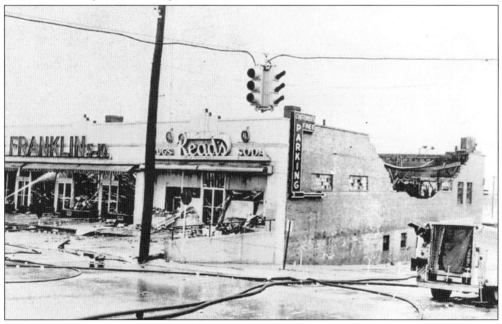

TABLE 9

IMPROVEMENTS DESIRED
ESSEX BUSINESS DISTRICT

	ESSEX SHOPPERS	TRADE AREA RESIDENTS
Supermarket	68.6%	42.9%
Apparel Shops	56.8%	41.6%
Entertainment (Movie Theater)	51.8%	24.3%
Personal Services	41.8%	15.0%
Restaurants	40.5%	18.1%
Government Service Center	21.8%	15.5%
More Parking	15.0%	25.7%
Traffic Flow Improvements	8.2%	10.6%

ESSEX REVITALIZATION PLAN. By the late 1960s and early 1970s, patronage in the Essex business district had declined significantly, resulting in vacant store space and decreased employment. The consulting firm of Murphy/Williams was engaged to study the problem. In July 1976, the first Essex Revitalization Plan was adopted as part of the Baltimore County Master Plan. The Essex business district, although rebuilt, had never bounced back after the great fire of 1957. New malls and shopping centers in the area drew residents to an attractive new way of suburban shopping. In 1978, an Essex Market Research Study was undertaken by the American City Corporation (ACC). Where Murphy/Williams called for facade improvements and expansion, the ACC plan recommended demolition and redevelopment. The county and community opted for renovations.

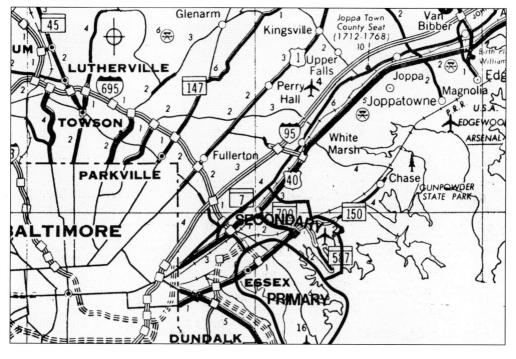

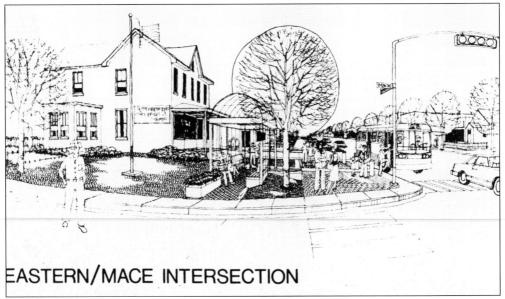

EASTERN/MACE INTERSECTION

REVITALIZATION CONCEPTS. The Essex Revitalization Plan of 1980 contained numerous artists' renderings suggesting possible scenarios for rehabilitation of the business district. Shown in these drawings are views depicting renovations of two intersections, Eastern at Mace Avenues and Eastern at Taylor Avenues. A program of extensive rehabilitation with a program of financial assistance for property owners was suggested. Among other recommendations were improvements to off-street parking, sidewalks, street lighting, pedestrian links to parking areas, and creation of public plazas.

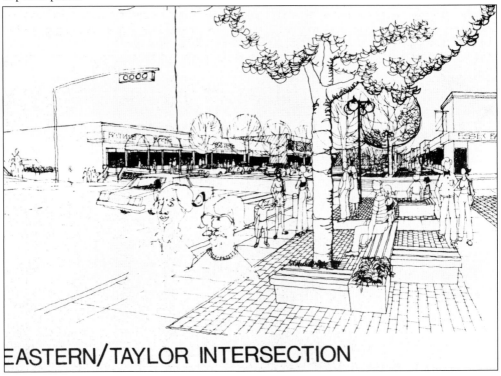

EASTERN/TAYLOR INTERSECTION

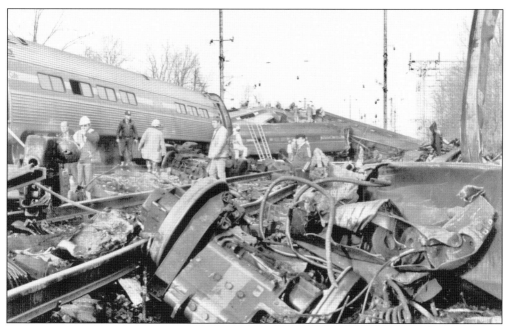

AMTRAK-CONRAIL TRAIN WRECK. On January 4, 1987, at about 1:30 p.m., Eastern Baltimore County became national news when Amtrak passenger train No. 94 rear-ended three Conrail engines at the Gunpowder Interlocking in Chase, Maryland. These photographs were taken by Gary Sullivan, an engineer, and Buzzy Marsh, a brakeman, both of whom worked for Conrail and resided near the scene. Neither was involved in the accident. The train crash occurred adjacent to the residential communities of Harewood Park and West Twin River, where neighbors rushed to help emergency response personnel and provide shelter for the injured. Community members and responders received many awards and accolades for their efforts. Fifteen passengers died in the crash along with the Amtrak engineer. (Courtesy William Woutila.)

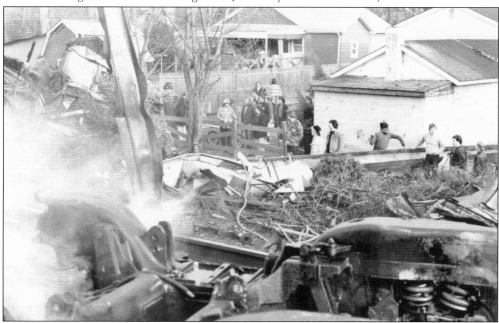

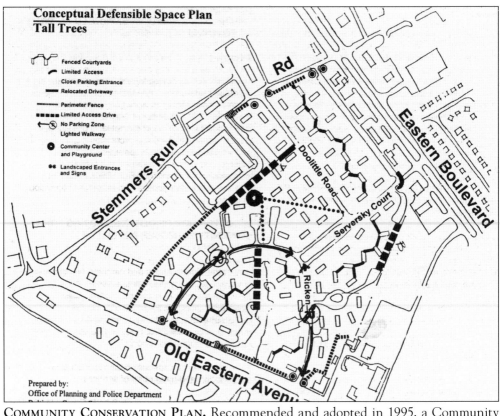

COMMUNITY CONSERVATION PLAN. Recommended and adopted in 1995, a Community Conservation Action Plan for Essex and Middle River presented yet another guide to solving the area's problems. Low-income and deteriorating housing was one focus of the effort that included extensive interaction with community and business leaders. Shown is a conceptual, defensible space plan designed to curtail crime in the Villages of Tall Trees apartment complex.

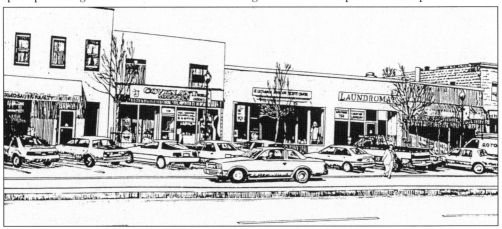

REVITALIZATION STRATEGY. The Eastern Baltimore County Revitalization Strategy was adopted by the Baltimore County Council in July 1996. With a study area of over 70 square miles, the plan was organized into smaller, more-manageable categories such as Economic Development, Community Conservation, Waterfront Enhancement, and Parks and Recreational Facilities. Shown is a drawing from the strategy book depicting the 400 block of Eastern Boulevard.

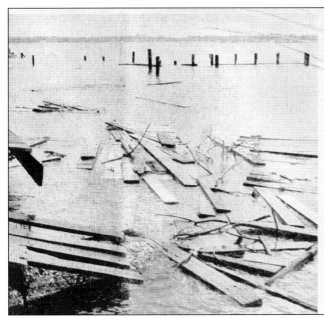

Mid-Atlantic storm swells rivers; 26 die

Thousands flee homes from N.C. to Pa.; W.Va. gets worst floods ever

Associated Press

Storm-swollen rivers roared out of their banks across the mid-Atlantic region yesterday, killing 26 people, forcing thousands to evacuate their homes and leaving others missing. Some looting was reported in areas cut off by the floods.

Some residents scrambled to safety on rooftops and in trees as flood waters inundated houses from North Carolina to Pennsylvania before the storm system, which had stalled over the Carolinas, crept slowly northward out to sea.

Hundreds of roads were submerged, some covered by up to 12 feet of water and others by mudslides, homes were washed away.

Governors in Virginia and Pennsylvania declared states of emergency for some areas.

NATURAL DISASTERS. In addition to economic strife, Essex has continued to experience its share of natural disasters. Hurricane Hazel in 1954, Agnes in 1971, and David in 1979 caused extensive damage, but a nor'easter in 1985 brought headlines as well. This clipping from the *Baltimore Sun* dated November 6, 1985, describes damage along the East Coast with a photograph of pier damages in the shorefront community of Rockaway Beach, Essex.

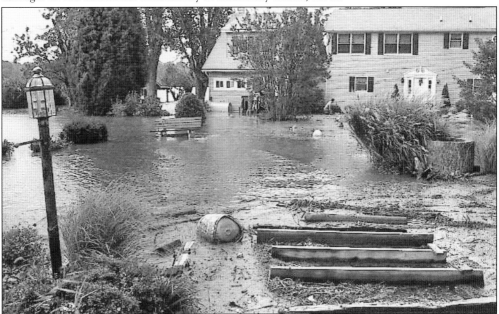

TROPICAL STORM ISABEL. It was a tidal surge rather than heavy winds that ravaged the waterfront of Essex and Middle River on September 18 and 19, 2003. Tropical Storm Isabel blew up into the Chesapeake Bay overnight, pushing tides 8–10 feet above normal. Water surrounded many homes such as this one on Sue Creek. Many homeowners were forced to evacuate and rebuild in the wake of the destruction. (Author photograph.)

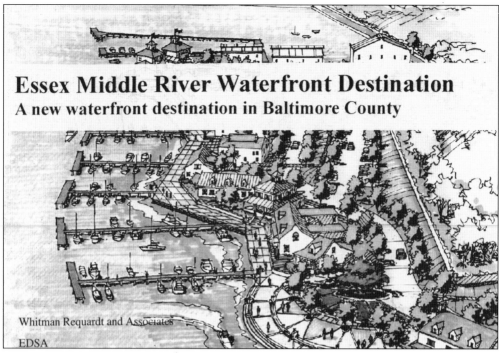

Essex Middle River Waterfront Destination
A new waterfront destination in Baltimore County

Whitman Requardt and Associates

EDSA

WATERFRONT DESTINATION. A $100,000 study suggesting redevelopment of three marinas on the Essex side of Middle River Bridge yielded colorful drawings and a professional report but little results in 2002. Marina owners, however, decided to proceed in different directions and at their own pace. Buedel's now has been sold and is being redeveloped with luxury townhomes and a private marina, while Riley's and Cutter Marine continue to improve their facilities.

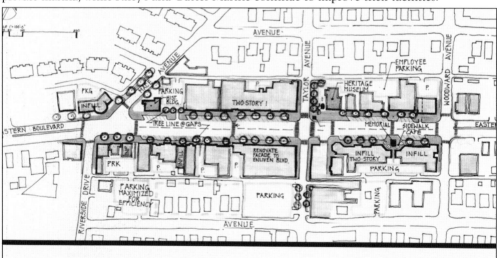

Essex needs to strengthen its community core by creating a distinctive shopping district. Local and authentic businesses can create a unique identity for Essex.

MAPPING THE FUTURE. The county and community continue to work on what has been designated the Renaissance of Essex–Middle River, and significant strides have been made. New housing continues to replace decaying apartments, businesses have been renovated, and new parks added to the revitalization area.

126

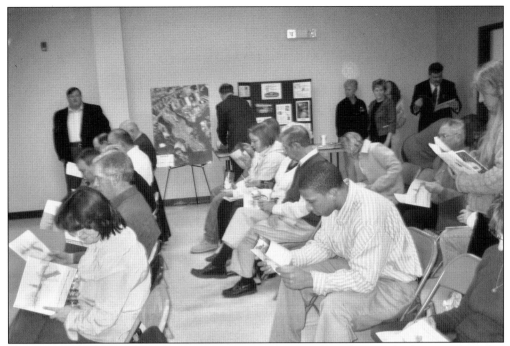

URBAN DESIGN ASSISTANCE TEAM. In May 2003, community and county leaders came together to create another vision for the future of Essex and Middle River. They brought together a team of experts from all over the East Coast to look at Essex's problems and, with community guidance, came up with a 21st-century vision for Essex. Recommendations were published in a report released in January 2005. (Author photograph.)

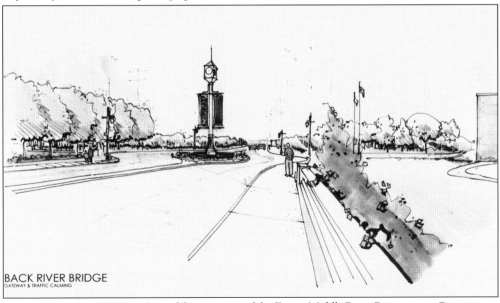

BACK RIVER BRIDGE
GATEWAY & TRAFFIC CALMING

RENAISSANCE INITIATIVES. One of the priorities of the Essex–Middle River Renaissance Corporation is to make a monumental statement at the Back River Bridge area to denote the business district. On the cover of the Urban Design Assistance Team report is a team member's design concept for a clock tower and landscaped island in the median heading east from the bridge.

127

ACROSS AMERICA, PEOPLE ARE DISCOVERING SOMETHING WONDERFUL. *THEIR HERITAGE.*

Arcadia Publishing is the leading local history publisher in the United States. With more than 3,000 titles in print and hundreds of new titles released every year, Arcadia has extensive specialized experience chronicling the history of communities and celebrating America's hidden stories, bringing to life the people, places, and events from the past. To discover the history of other communities across the nation, please visit:

www.arcadiapublishing.com

Customized search tools allow you to find regional history books about the town where you grew up, the cities where your friends and family live, the town where your parents met, or even that retirement spot you've been dreaming about.